ATLANTA
THEN & NOW

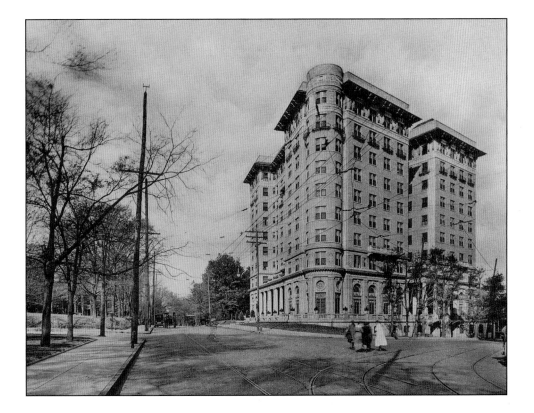

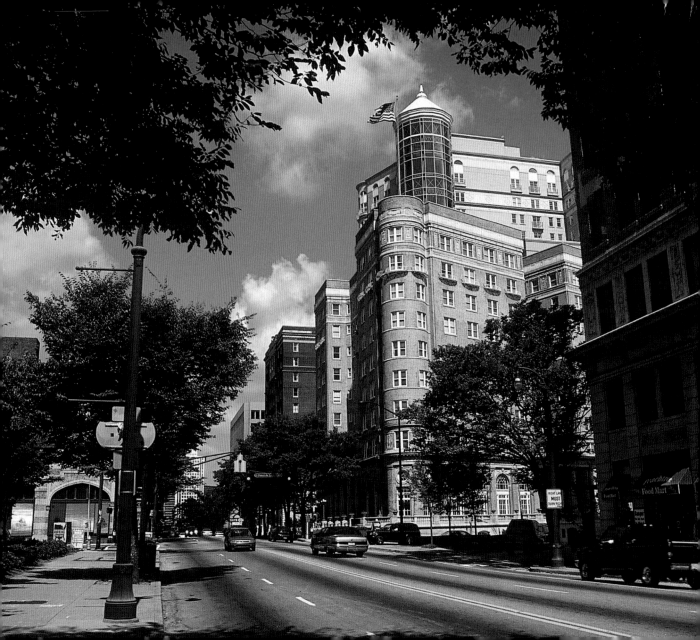

ATLANTA
THEN & NOW

MICHAEL ROSE

THUNDER BAY
P·R·E·S·S

San Diego, California

Thunder Bay Press
An imprint of the Advantage Publishers Group
10350 Barnes Canyon Road, San Diego, CA 92121
www.thunderbaybooks.com

Produced by Salamander Books,
an imprint of Anova Books Company Ltd.,
10 Southcombe Street, London, W14 0RA, United Kingdom

"Then and Now" is a registered trademark of Anova Books Ltd.

All notations of errors or omissions should be addressed to Thunder Bay Press, Editorial
Department, at the above address. All other correspondence (author inquiries, permissions)
concerning the content of this book should be addressed to Salamander Books,
10 Southcombe Street, London, W14 0RA, United Kingdom.

ISBN-13: 978-1-59223-874-3
ISBN-10: 1-59223-874-2

The Library of Congress has cataloged the original Thunder Bay edition as follows:

Rose, Michael, 1955-
 Atlanta then & now / Michael Rose
 p.cm.
 ISBN 1-57145-474-8
 1. Atlanta (Ga.)--Pictorial works. 2. Atlanta (Ga.)--History--Pictorial works. I. Title:
Atlanta then and now. II. Title

 F294.A843 R67 2001
 975.8'231--dc21
 2001017405

Printed and bound in China

1 2 3 4 5 12 11 10 09 08

ACKNOWLEDGMENTS

The publisher wishes to thank the following for their kind permission to reproduce the
photography for this book:

All Then photography courtesy of the Atlanta History Center.

All Now photography was kindly provided by:
Cotten Alston—pages 49 (inset), 61, 113 (inset)
Simon Clay—pages 7, 15, 17, 21, 35, 37, 41, 43, 47, 51, 53, 55, 57, 59, 63, 67, 69, 71, 73,
79, 81, 83, 85, 91, 93, 99, 105, 107, 113, 117, 119, 121, 125, 141
William F. Hull—pages 11, 13, 89, 137
Michael Rose—pages 9, 19, 23, 25, 27, 29, 31, 33, 39, 45, 49, 75, 77, 87, 95, 97, 101, 103,
109, 111, 115, 123, 127, 129, 131, 133, 135, 139, 143
Rod Smith—page 65

Anova Books is committed to respecting the intellectual property rights of others. We have
therefore taken all reasonable efforts to ensure that the reproduction of all content on these
pages is done with the full consent of copyright owners. If you are aware of any unintentional
omissions, please contact the company directly so that any necessary corrections may be made
for future editions.

INTRODUCTION

Peachtree. A name mystic and magical, its source lost in the myths of history—you can hunt for it on the map, but it won't be there. No one knows the true Peachtree, neither a factual peach tree—itself an exception in the Georgia Piedmont—nor a figurative pitch tree or, rather, a pine tree from which Native Americans obtained resin, or "pitch." In either case, the source of the Peachtree was located where a stream, now known as Peachtree Creek, flows into the Chattahoochee River. This place came to be known as Standing Peachtree. From here grew an Indian settlement, a trading center, a post office, and a fort. By the time the railroads came, however, and Atlanta's site was settled, the tree of origin was gone.

Yet at that time, Peachtree was not a name of significance; Atlanta was too busy naming itself. The city was known initially as Terminus—literally the end of the railway line for which it was founded in 1837. Incorporated six years later, it was called Marthasville for the young daughter of onetime Democratic governor and senator Wilson Lumpkin. It was Lumpkin who oversaw the removal of the last of the Native Americans whose river village gave us Peachtree. When the community's name changed in 1847, it became Atlanta—ostensibly derived from the important Western & Atlantic rail line leading into town, though arguably still named for the politician's daughter, whose middle name happened to be Atalanta.

Today, Peachtree is the name of a street—one known worldwide—and is itself the source of many more: Peachtree Road, Peachtree Circle, West Peachtree. The list—and the confusion—is constant. Yet the original Peachtree, identified in its various sections as Peachtree Street, Peachtree Road, and Peachtree Industrial Boulevard, is an axis known by almost all Atlantans and along which much of the city's history has played out. Peachtree is also a word with inferences: speak it, and many will immediately know Atlanta. Along with that will come associations imbued with popular culture—worldwide, this means Civil War battles or Scarlett O'Hara and *Gone With the Wind*. More recently, it means Coca-Cola, CNN, and the 1996 Olympics. Regionally, it means big city, big business, and urban business boom.

This book is the history of a street, from dusty crossroads to gleaming high-rise office towers. Much of its journey is along the course of the street itself and includes seminal events in the city's history that defined what Atlanta is, or represents: the Civil War, the 1895 World's Exposition, Margaret Mitchell, Martin Luther King Jr. Along the way, it visits sites beyond Peachtree representing important influences on the city or depicts trends characterizing Atlanta: the railroads and residential development. But always, it follows the constant northerly flow of urban development along Peachtree.

This publication is also a record of change and preservation. The old downtown once defined by the railroad lines has now vanished as the result of attempts to provide safe and continuous street access over the railways. A system of bridges was constructed above the old streets surrounding the rail depot. With overpasses one story above the street, the second story in effect became the first floor and the original street level was now underneath, or Underground. In the late nineteenth century, Peachtree, north of the business district—known as Upper Peachtree—was a promenade of palatial homes and beautiful grounds. With few exceptions, those have given way to office buildings and commercial development. As growth spread further north along Peachtree, the rural community of Buckhead was energized in the 1980s and 1990s, and now exists as the shopping, dining, financial, and office hub of Atlanta.

Along the way, the old homes, early business districts, and original architecture have been torn down; in many cases their original sites are totally unrecognizable. Here and there along the way, however, are scenes of preservation: Oakland Cemetery, Inman Park's Trolley Barn, the Castle, and the Tullie Smith Farm. In some cases there are hints of what used to be there: the remains of the Carnegie Library at Hardy Ivy Park, the stone steps throughout Piedmont Park, a plaque reminding us where Margaret Mitchell's childhood home once stood.

Atlanta is not necessarily a city with a strong link to its past—in its rush, too much of its history has been pushed aside; many, in fact, would like to forget the past. Hopefully, this book will provide some with a link to an earlier Atlanta, and the next time they pass by Underground Atlanta, Little Five Points, or the Fox Theater, they will think of what once was there.

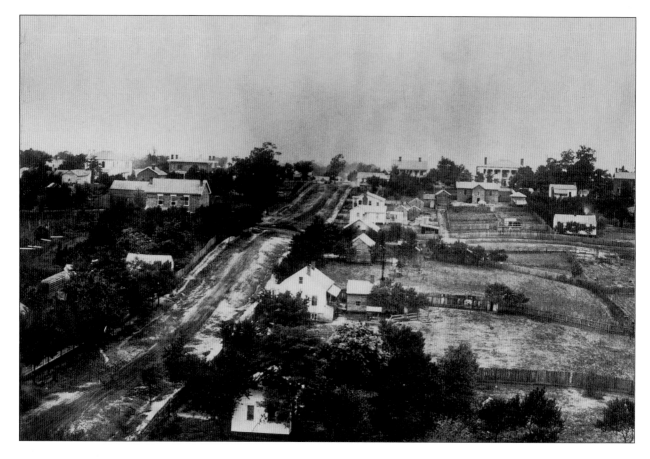

Atlanta seen from the dome of the Atlanta Female Institute in the fall of 1864 following the city's surrender to Union troops during the Civil War. The streets are empty, the result of Major General William T. Sherman's evacuation order sending residents into exile. The unpaved road running west into the distance is Ellis Street, crossing Ivy Street (now Peachtree Center Avenue) in the middle and cresting at the ridgeline, marking the intersection with Peachtree Street. The white, columned house right of center is the Herring-Leyden House, current site of Macy's downtown department store.

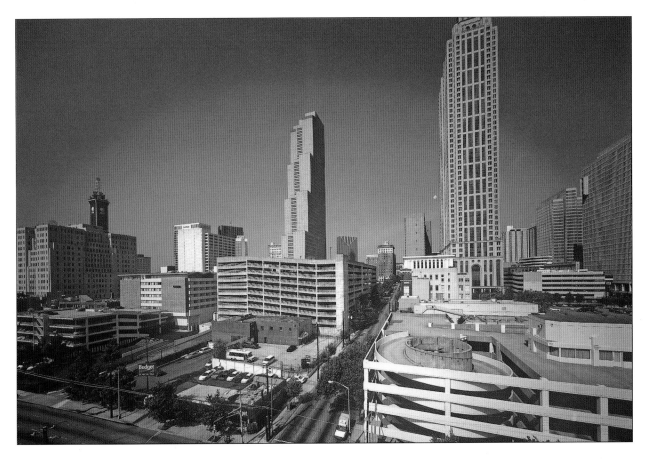

Looking west along Ellis Street today, the stepped building at center
is the Georgia-Pacific Center, situated at Margaret Mitchell Square—
the heart of the Peachtree corridor representing much of what people
worldwide think of as "Peachtree Street, U.S.A." At right rises 191
Peachtree Tower.

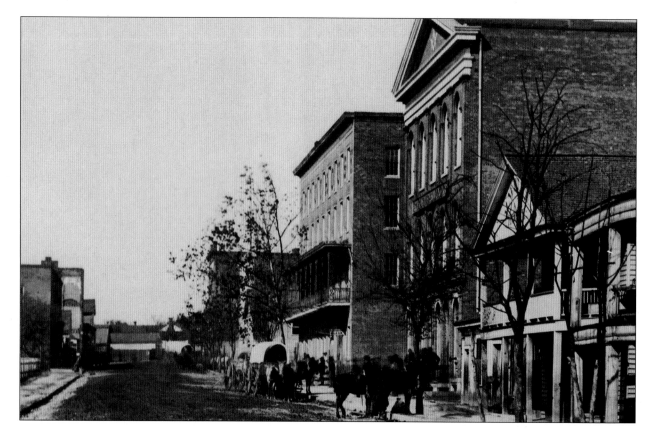

In 1842, Thomas Cruselle built the first house on Decatur Street. In this 1864 scene, the Trout House, the city's largest hotel, and the pedimented Masonic Hall stand at right. Atlanta's first city park, Public Square, was across the muddy street, and the city's passenger depot, later destroyed by Sherman's troops, stood on the other side of the square. Atlanta's other public space, State Square, was on the far side of the depot's tracks, the rail line bisecting the public space as it did all of downtown.

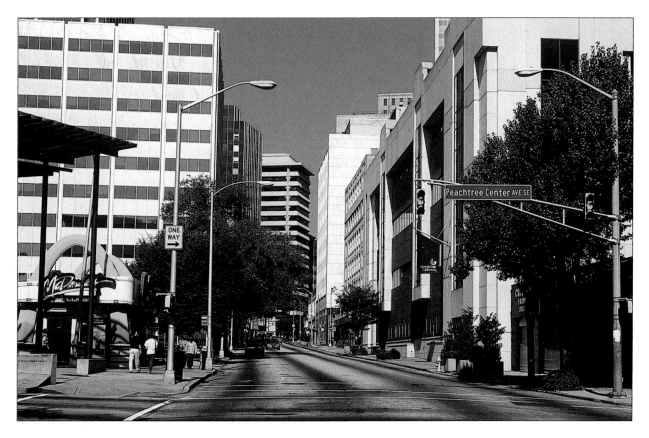

Decatur Street looking toward Five Points from the same intersection. The cross street, originally called Loyd Street after Atlanta pioneer James Loyd, is now named Central Avenue to the left and Peachtree Center Avenue to the right. The building at right is Georgia State University's Natural Science Center. Consisting of over 30,000 students, GSU is Georgia's second-largest university and maintains thirty-five buildings in the downtown area.

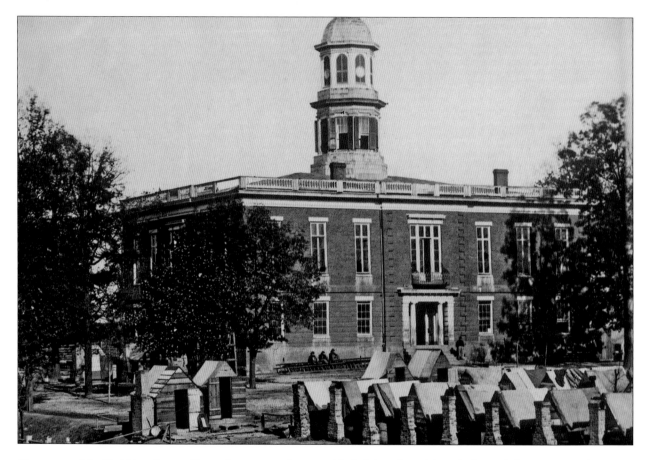

The quarters of the 22nd Massachusetts, Sherman's provost guard, occupied the grounds of Atlanta City Hall in the fall of 1864 following a four-month campaign. Seen from the front porch of Sherman's headquarters, the Neal-Lyon House at the corner of Washington and Mitchell (now Capitol Square), the city hall was constructed in 1854. The building also served as the Fulton County Courthouse until it was demolished in 1884 to make way for the current state capitol.

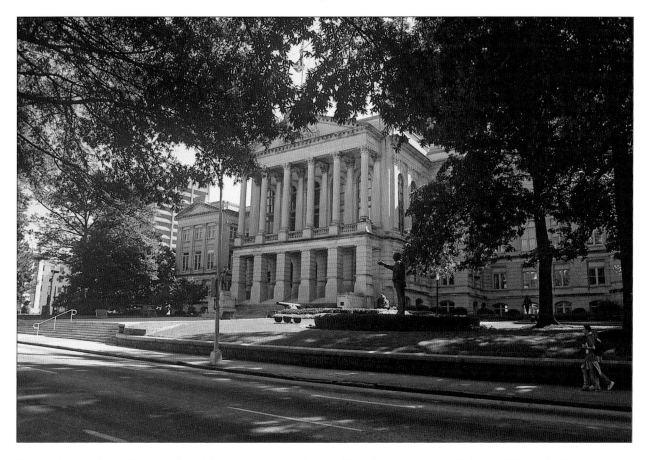

Restricted to spending under one million dollars and yet entrusted with building a sufficiently imposing state capitol, the Capitol Commission completed its work in 1889 with a classically influenced, domed building constructed of fire-resistant iron and Indiana limestone masonry—and $118 in the bank. The famous gold on the dome was not added until 1959, supplied by wagon train from the north Georgia mining town of Dahlonega. An extensive interior restoration has recently returned the Georgia Assembly chambers to their original nineteenth-century appearance.

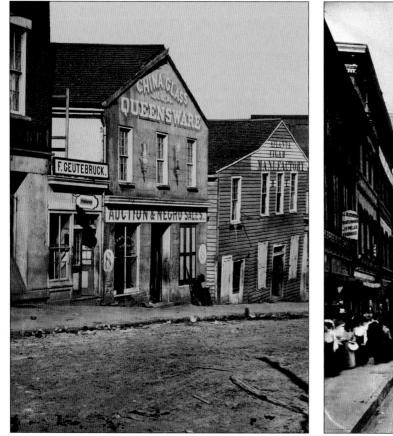

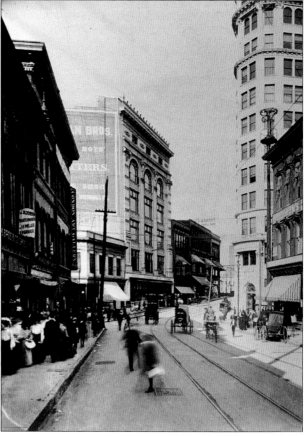

In 1864, Crawford, Frazer & Company's slave market was located beneath Thomas R. Ripley's tableware shop at number 8 on the northwest side of Whitehall Street between the railroad tracks and Alabama Street. Alongside stood Geutebruck's tobacco shop, the Atlanta Cigar Manufactory, and Theodore Gilbert's jewelry store, visible at left.

The same stretch of street in 1902 was dignified by the Eiseman Brothers clothing store; number 8 was occupied by John Lynch's tailor shop.

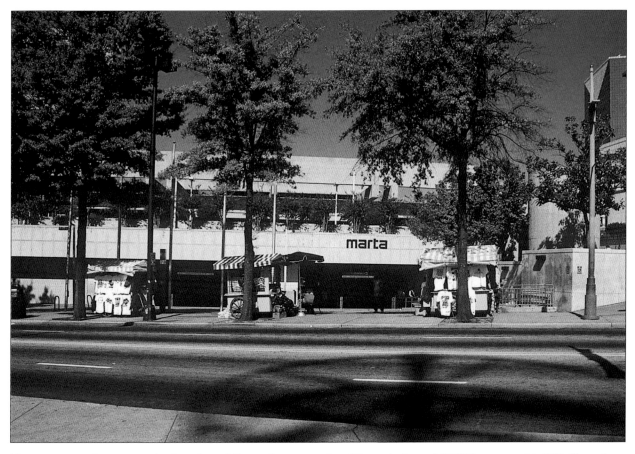

The same section of street is now Peachtree Street following the renaming of seven blocks of Whitehall in the 1970s. In the block where the slave market and Eiseman Brothers once stood is the entrance to the Five Points station of the Metropolitan Atlanta Rapid Transit Authority (MARTA), constructed in 1979. Three of the arched windows with their allegorical figures from the facade of the Eiseman Brothers building are installed in a lower level within the subway station.

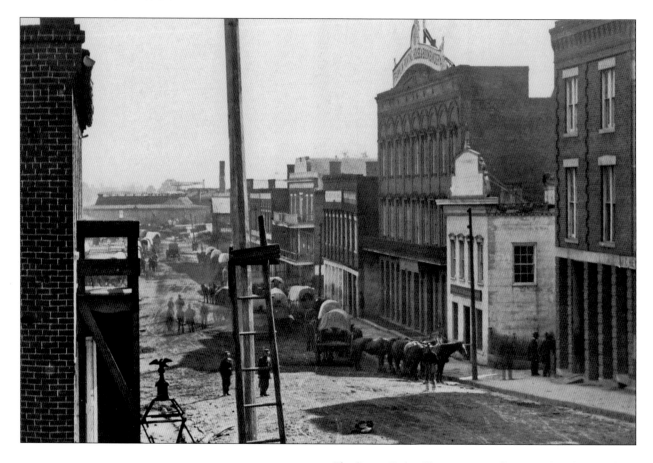

The Georgia Railroad locomotive roundhouse stands at the far end of a dusty Alabama Street filled with Union troops during the occupation of Atlanta, September through November 1864. Looking east from Whitehall (Peachtree) Street, the white building at right is the Atlanta National Bank and next to it is the Franklin House & Bookbindery. Most Atlanta streets remained unpaved until 1882.

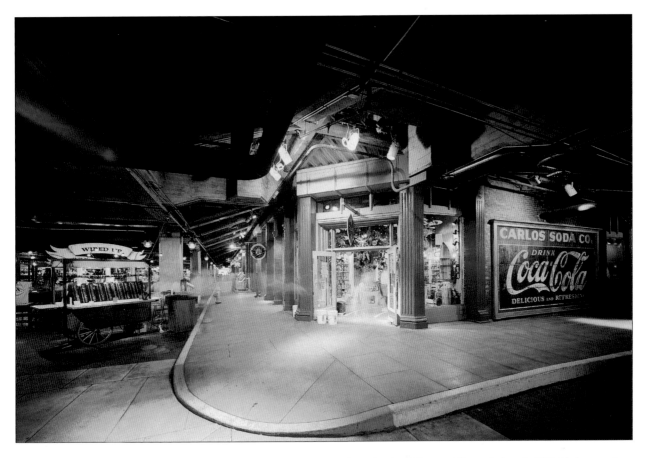

The original street level of Alabama Street, now known as Lower Alabama, is the heart of Underground Atlanta, created by the viaduct system bridging the train gulch. Beginning in 1968, this area became a popular nightspot filled with bars and clubs; by 1981, however, the last of these closed and the area fell into decline. In 1989, Underground Atlanta reopened as a festival marketplace with specialty shops, food courts, and entertainment.

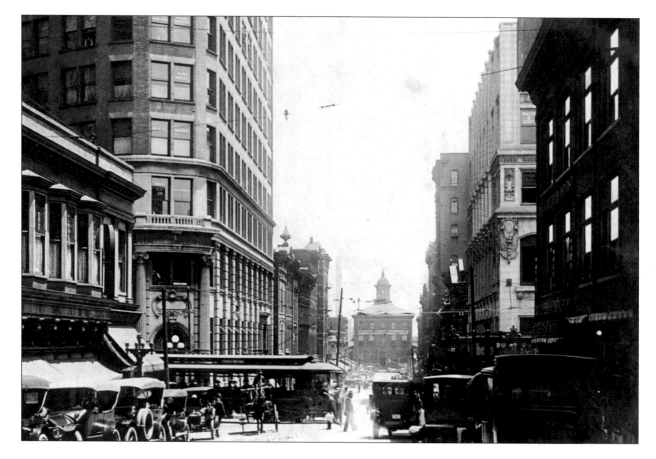

The Georgia Railroad freight depot stands at the foot of Alabama Street, looking south from Whitehall (Peachtree) Street prior to construction of the viaduct system. Crowned by a cupola, the building was finished in 1869 and symbolized the rebuilding of the city following the destruction of the Civil War. At left stands the Century Building, constructed in 1902; the building would lose the first floor of its Alabama Street facade when the viaducts were built in the late 1920s.

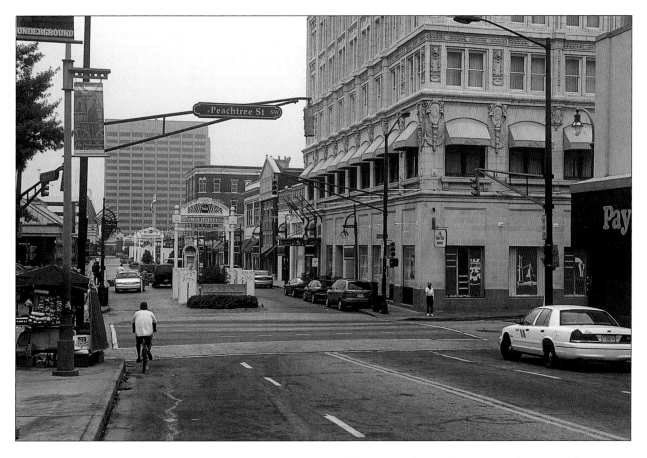

Only the first floor of the freight depot remains and Upper Alabama Street's buildings now house shops, restaurants, hotels, and the Atlanta Visitors Center at Underground Atlanta. The Suite Hotel at right was originally the Connally Building, built in 1916. Where the Century Building once stood is Peachtree Fountain Plaza. Here, Atlantans gathered to hear the announcement of the city's selection as the site of the 1996 Olympics. Each year, many come to the plaza to celebrate New Year's Eve with the dropping of a giant peach at midnight.

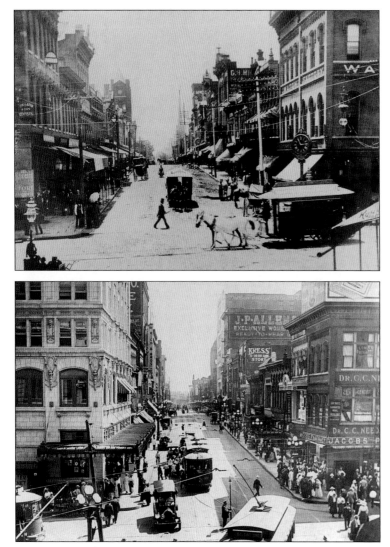

Left: Looking west along Whitehall Street, two horse-drawn trolleys and a top-hatted gentleman converge at the Alabama Street intersection in 1882. Named for the White Hall Tavern that stood west of here along the stagecoach line, this was Atlanta's premier retail street during the nineteenth and early twentieth centuries, as witnessed by the auto, trolley, and foot traffic in the 1920s (*below left*).

Right: By the 1950s and 1960s, however, the shops and retail merchants once lining Whitehall relocated to suburban malls (and up Peachtree), leaving storefronts empty. In an effort to regain shoppers, the city government extended Peachtree Street, ostensibly renaming seven blocks with the magical Peachtree name, hoping it would appeal to investors.

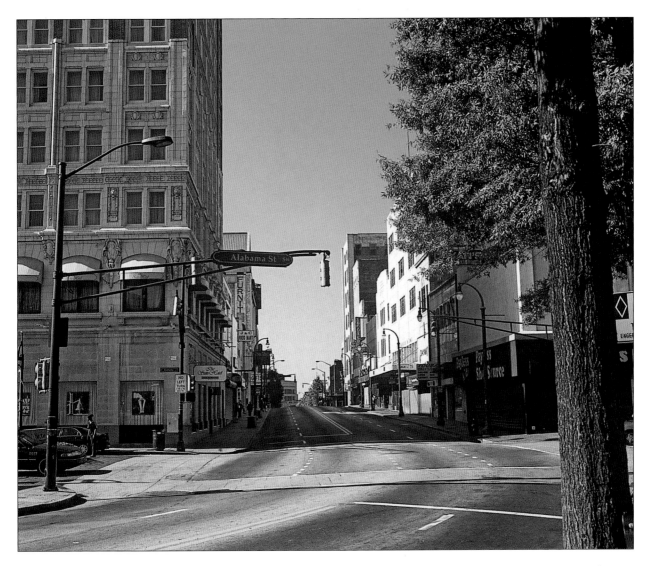

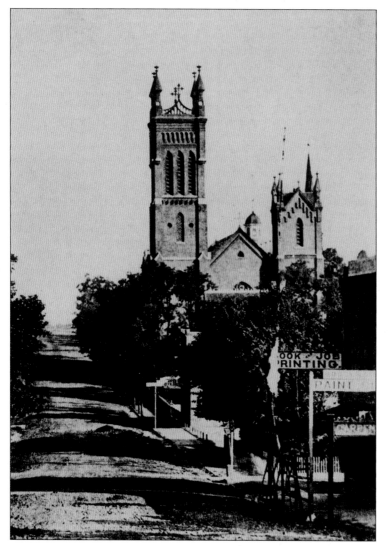

The Shrine of the Immaculate Conception stands along a tree-lined street at the corner of Hunter and Loyd streets (now Martin Luther King Jr. Drive and Central Avenue) in 1875. The original church on this site, built in 1848, was saved from total destruction during the Civil War by the efforts of its priest, Father Thomas O'Reilly. Nevertheless, damaged during the war, it was replaced with the current building in 1873. Beyond the church, between its two dissimilar spires, appears the cupola of the Atlanta City Hall.

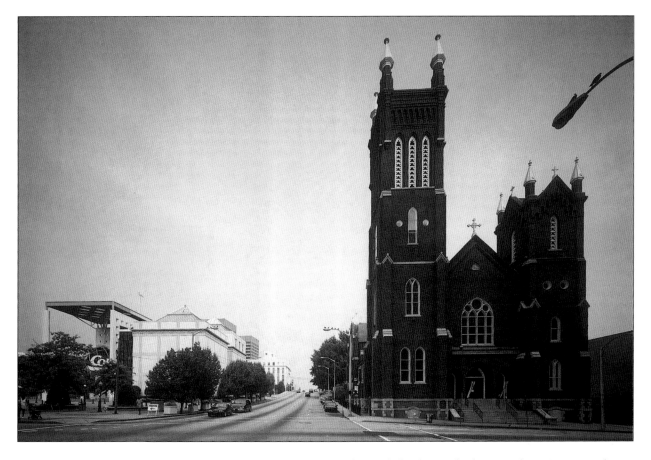

Trees still line the street, now named Martin Luther King Jr. Drive in honor of the native-Atlanta civil rights leader, and the Catholic church remains as Atlanta's oldest religious institution. At left is the World of Coca-Cola Pavilion—constructed in 1990 and located at the southern end of Underground Atlanta, it is the city's most visited indoor attraction. The giant neon Coca-Cola sign is reminiscent of the sign that stood for nearly fifty years at Margaret Mitchell Square.

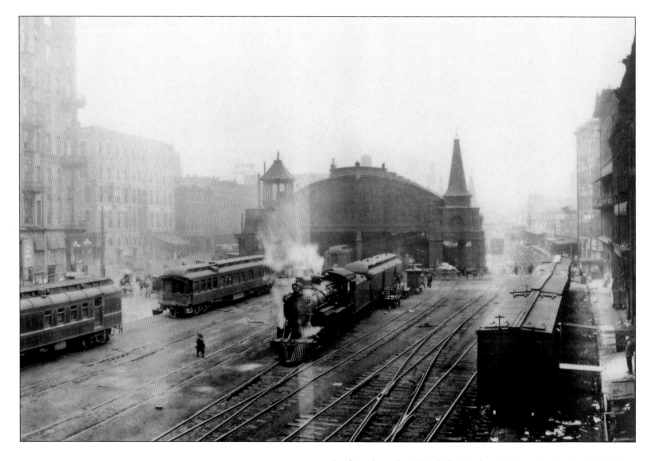

Looking from the Whitehall (Peachtree) Street viaduct in 1914, this scene portrays the very heart and soul of the city: the smoky, noisy train gulch. With commerce based on trade and transportation, Atlanta's existence was tied to the rail lines on which it was founded. Yet the same lines were difficult and dangerous to cross, leading to the development of the raised viaduct system.

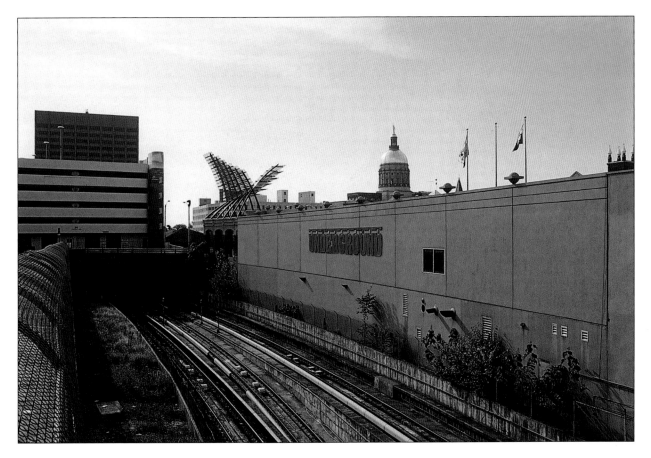

A sign proclaims the location of Underground Atlanta, and the former depot site, left of the rail line, is currently a parking lot. With its unmatched towers, the Union Passenger Depot was the second station on the same spot. Constructed in 1871, it replaced the train shed destroyed by Sherman during the Civil War and was demolished in 1931. The gilded dome of the Georgia State Capitol appears above; the sculpture atop the Underground building represents the city's symbol, the phoenix.

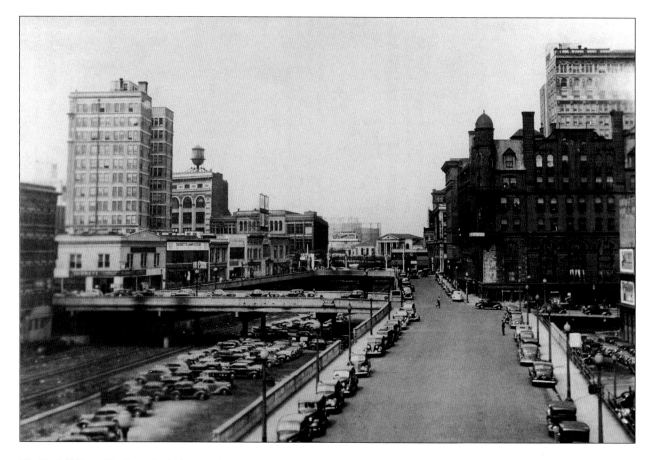

The Kimball House Hotel at right, built in 1885, was once considered the South's premier hotel, featuring a seven-story atrium and an architectural style considered a combination of "Old Dutch, the Renaissance, and the Queen Anne." In the distance is the classical portico of Union Station, opened in 1930, where a huge Atlanta crowd greeted golfer Bobby Jones that year when he returned from his Grand Slam victories in the U.S. Amateur, U.S. Open, British Amateur, and British Open.

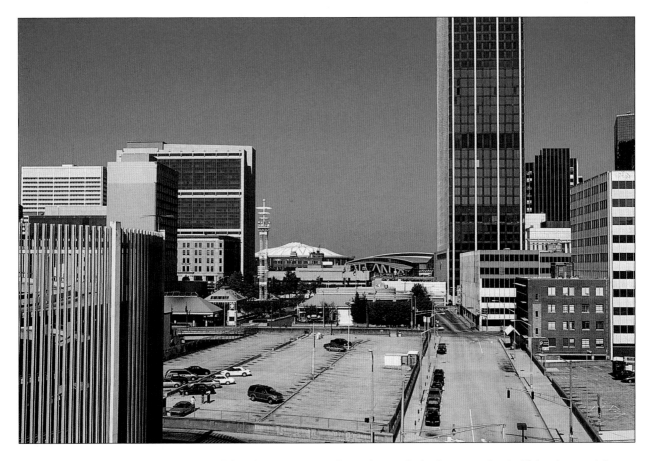

With the Kimball House demolition in 1959 and that of Union Station in 1972, the remnants of Atlanta's origins as a rail center disappeared from downtown. The forty-one-story Wachovia Bank of Georgia Building, however, represents the city's growth as a banking and financial center. In the distance can be seen Philips Arena and the Georgia Dome; the white tower at left is Peachtree Fountain Plaza, the entrance to Underground Atlanta.

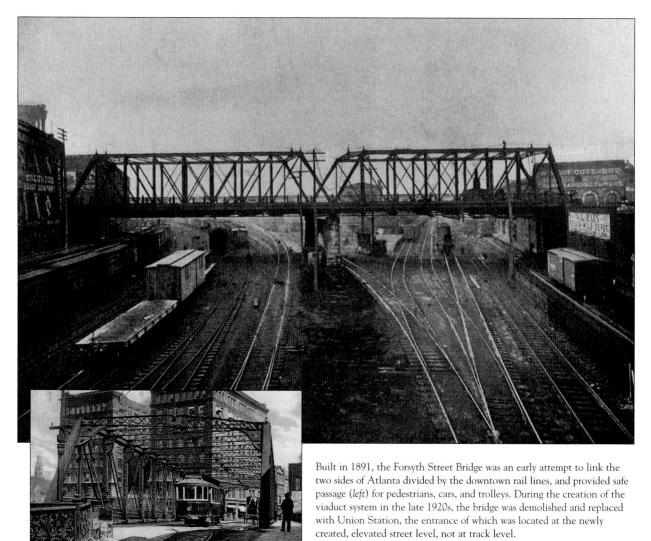

Built in 1891, the Forsyth Street Bridge was an early attempt to link the two sides of Atlanta divided by the downtown rail lines, and provided safe passage (*left*) for pedestrians, cars, and trolleys. During the creation of the viaduct system in the late 1920s, the bridge was demolished and replaced with Union Station, the entrance of which was located at the newly created, elevated street level, not at track level.

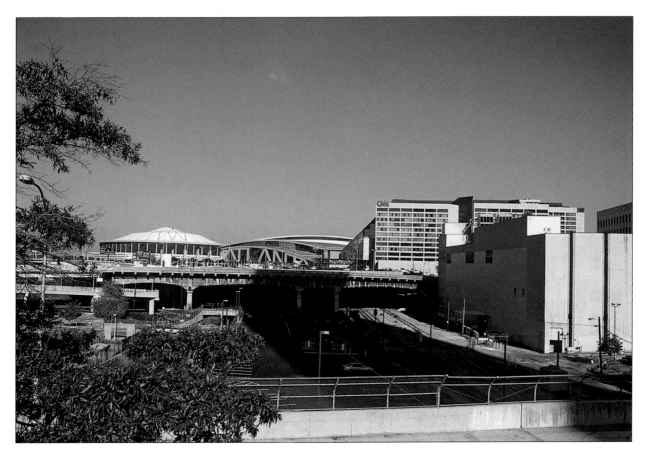

Looking from the present Forsyth Street Bridge, the rail lines have largely been replaced with parking lots and underground streets. In the distance, where water towers, railroad shops and roundhouses, and more rail lines once dominated, are the Georgia Dome, built in 1992;

Philips Arena (whose facade spells out "ATLANTA"), built in 1999; and CNN Center (built in 1976 and renovated in 1999), headquarters of the international news organization.

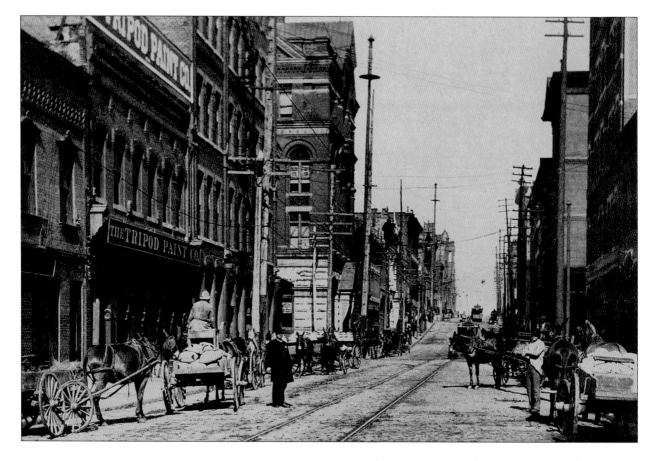

A city policeman oversees the unloading of mule-drawn delivery wagons along cobblestoned Alabama Street in 1895. Looking toward Pryor Street, the tall brick building at left, constructed in 1882, is the Frank E. Block Building, named for the grocery wholesaler and manufacturer of candy and crackers. This street level is now Lower Alabama in Underground Atlanta.

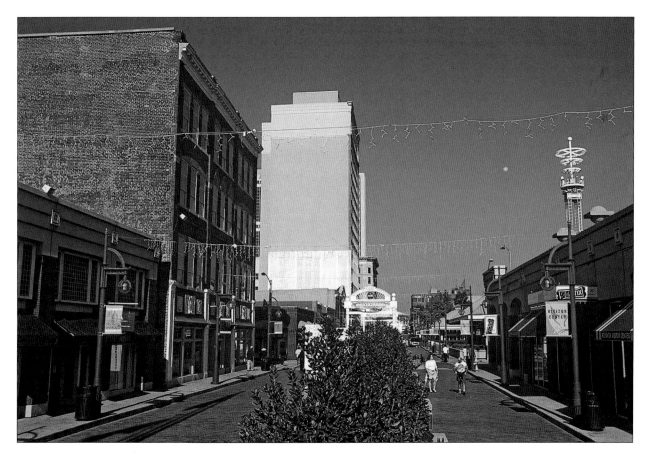

Upper Alabama Street today, one level above the photo at left, is a
pedestrian mall across Peachtree Street from the Five Points MARTA
station. An example of the effects of the viaduct system creating
Underground Atlanta, the building at left is the same Block Building
seen in the 1895 photo—but pictured here are only the top four stories
because the first floor is now below the new street level.

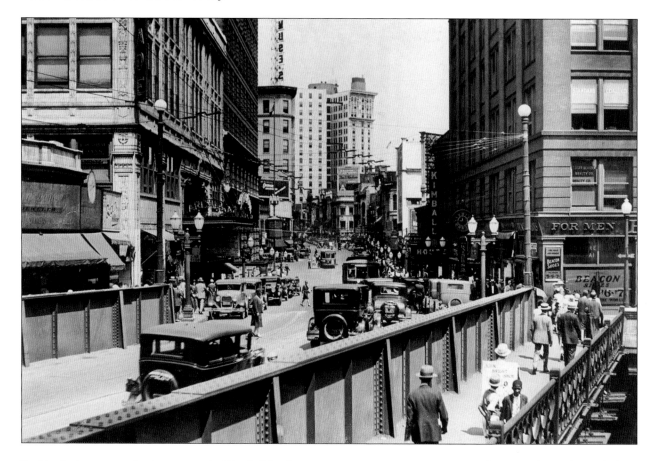

Steel barricades protect pedestrians crossing the Whitehall Peachtree Street viaduct, looking toward the Candler Building. The Peachtree Arcade building at left ran along an area known as the Great White Way for its illuminated streets and sidewalks, designed to make the area attractive to evening customers. Built in 1917, the arcade stretched one city block between Peachtree and Broad streets and was the city's first enclosed shopping and entertainment mall.

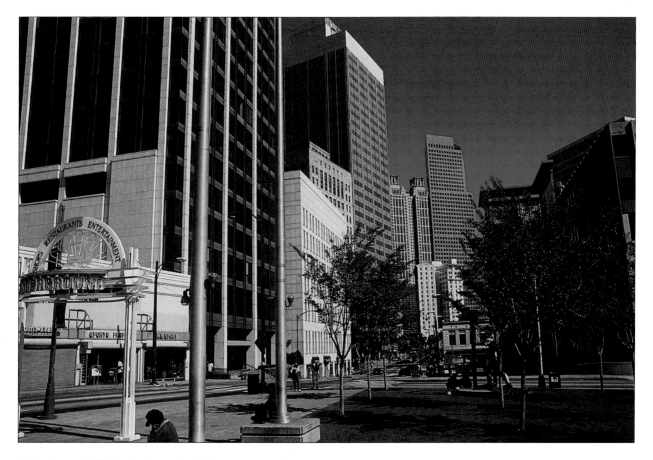

Taken down in 1964, the Peachtree Arcade's location is now the site of the Wachovia Bank of Georgia Building. Where street barricades once extended, today there is an open park area at the entrance to Underground Atlanta. In the distance, modern skyscrapers, including the stepped Georgia-Pacific Center, now dwarf the Candler Building.

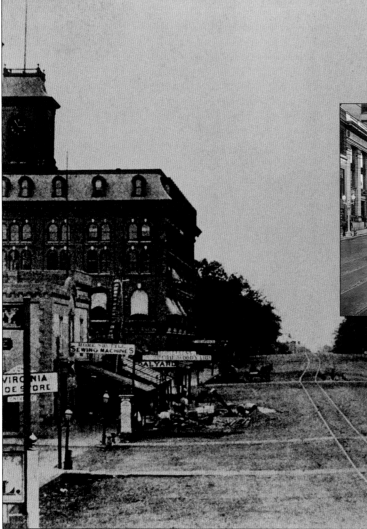

Left: The city's first state capitol building was on Marietta Street. Begun as an opera house, the unfinished building was purchased by the legislature when the state capital moved to Atlanta in 1869. They met there until 1889, when the present capitol building was occupied. It is seen here in 1875. Marietta has always been one of Atlanta's main thoroughfares (*below*).

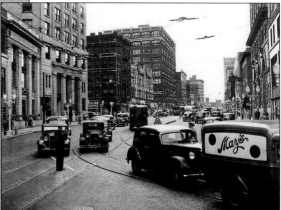

Right: To the left along a street dominated by modern glass-box office buildings, the eye-catching facade of the Forty Marietta Building, built in 1964, commands attention. The classical arches in the building at right belong to the Bank of America. Constructed in 1901 as the Empire Building, its lower three floors were redesigned in 1929 by prominent Atlanta architect Philip T. Shutze as headquarters for the Citizens and Southern National Bank.

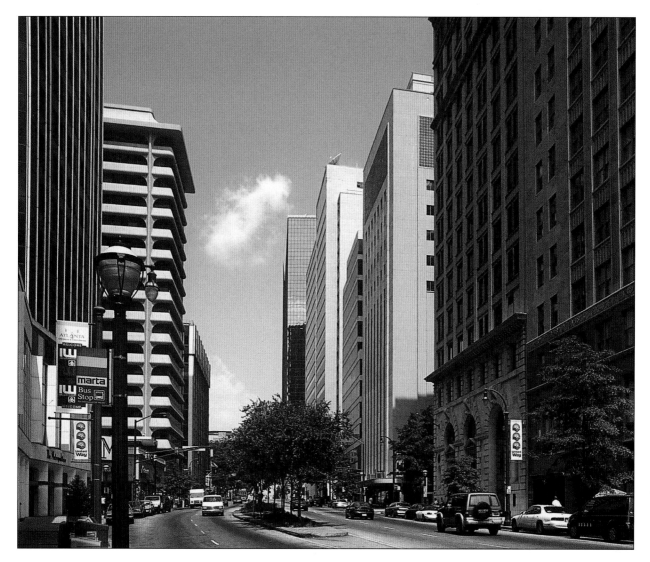

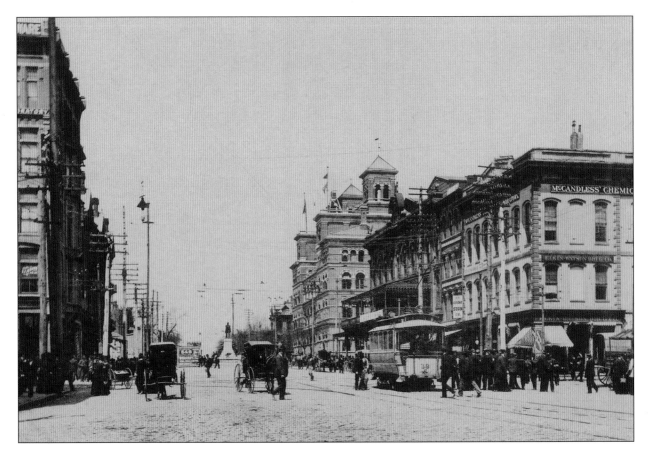

The Henry W. Grady Monument, dedicated to the influential speaker and newspaper editor, stands in the distance in the center of Marietta Street looking from Five Points in 1895. The flamboyant building at right is the U.S. Post Office and Custom House, constructed in 1878 in High Victorian Gothic style; it later served as Atlanta's city hall from 1910 until its demolition in 1930.

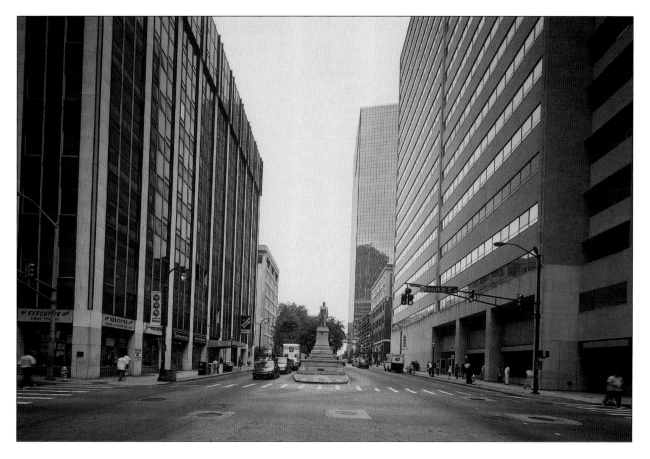

Henry Grady stands today in a canyon of glass boxes dedicated to money. Once the financial heart of Atlanta where banks, savings and loans, and the Federal Reserve located their headquarters, in recent years the area has seen many old financial institutions relocate their offices to Buckhead or merge with out-of-town partners.

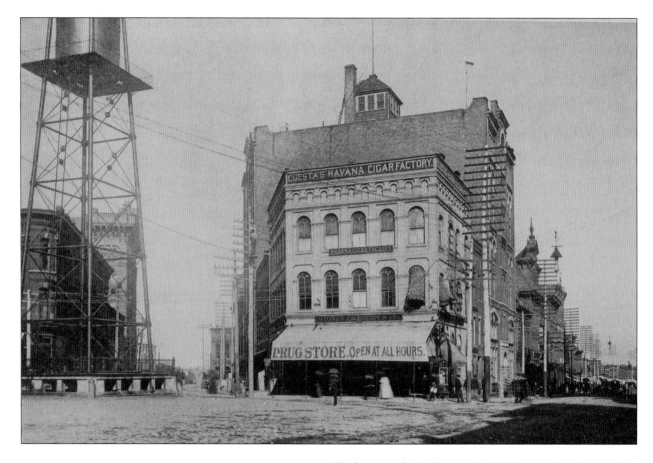

The business and cultural center of early Atlanta was Five Points—the convergence of Peachtree, Edgewood, Decatur, and Marietta streets in downtown. Looking east along Edgewood at left and Decatur at right, the city's artesian well stands almost in the middle of the intersection. In an effort to ensure the city's water supply, a well was dug here in 1884; never a reliable source of sanitary water, its use was discontinued in 1893.

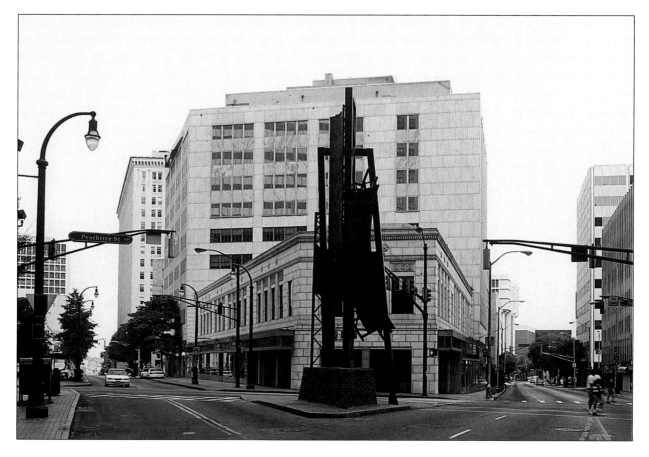

Reflecting the influence of the nineteenth-century water well, a
modern sculpture now rests near where the artesian tower once stood.
Long associated with Atlanta and known almost as well as Peachtree,
the term "Five Points" actually only originated within the last century,
first appearing in print in the 1910s.

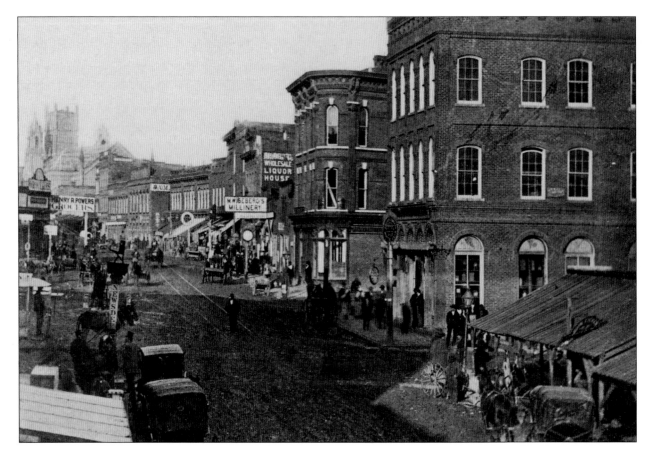

Looking north along Peachtree Street from the Five Points area in 1875—surprising to most Atlantans today would be the cathedral-like church in the distance. This is the First Methodist Church, which was built in 1871 on the site of two previous churches: Wesley Chapel, built in 1848, and a nondenominational building erected in 1847.

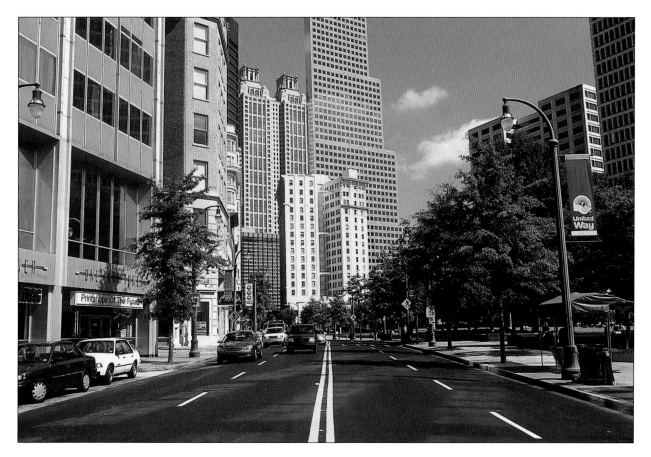

Woodruff Park, offering the best view of downtown Atlanta's
architecture, opened in 1973 as Central City Park, supported by
an anonymous donation that paid for the purchase of the land and
development. Twelve years later, it was renovated and renamed for
the anonymous donor, Coca-Cola president Robert W. Woodruff.

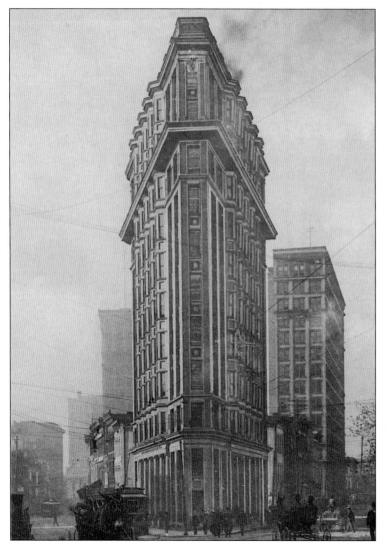

Completed in 1897 as the English-American Building, Atlanta's Flatiron Building stands on a narrow triangular lot bounded by Peachtree, Broad, and Poplar streets, part of the historic downtown Fairlie-Poplar District. Designed by architect Bradford Gilbert, who built the nation's first steel-framed skyscraper, the building predates New York's more famous Flatiron by five years.

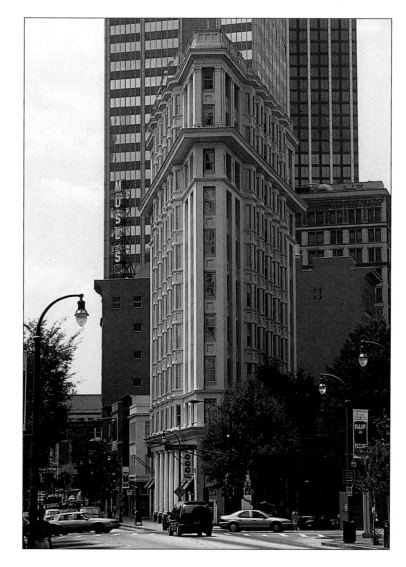

Where it once dominated the skyline, the Flatiron is now more notable among its taller neighbors as Atlanta's oldest surviving skyscraper. Despite several interior renovations, the exterior design appears principally unchanged in the Chicago School's Commercial Style of architecture, although its five Ionic columns facing Peachtree Street were painted bright red during the 1996 Olympics.

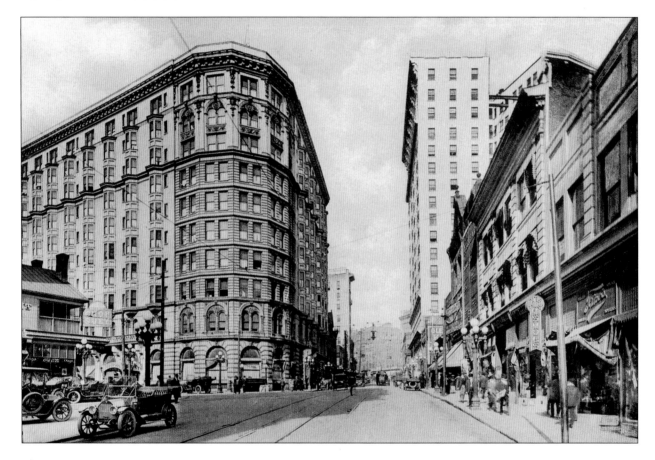

Constructed in 1903, the Piedmont Hotel towers over Peachtree
Street and the chop suey restaurant located to its left (which carries
a Coca-Cola ad out front) at the intersection of Broad and Luckie
streets. The Piedmont Hotel marked the trend of hotels in the 1890s
to advance north along Peachtree Street beyond the area adjacent to
the passenger depot.

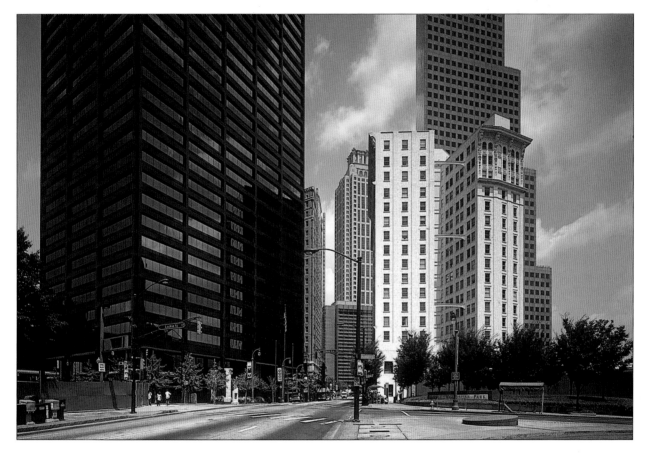

Opened in 1968, the sleekly black Equitable Building now occupies the site of the Piedmont Hotel. Standing stark white against its modern rivals, the triangular-shaped Candler Building actually faces Peachtree Street, turning its distinctive V-shaped back to Woodruff Park in the foreground. Covered in white Georgia Amicolola marble, it was built by Coca-Cola founder Asa G. Candler. When its cornerstone was laid in 1904, a bottle of Coca-Cola was included along with the other objects.

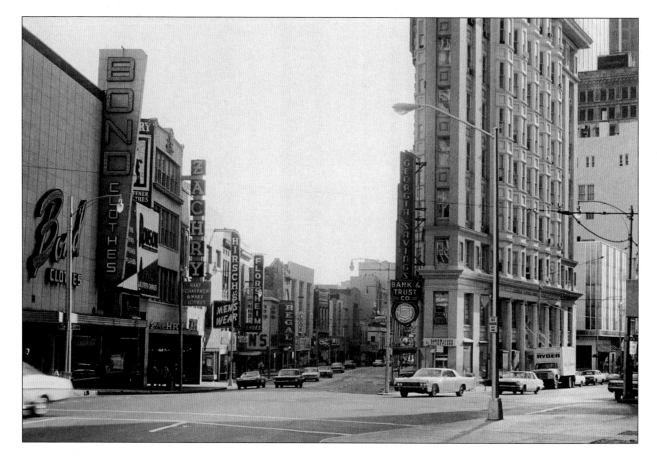

In the mid-1960s, Peachtree Street between Five Points and Margaret Mitchell Square was still a small valley of business establishments, including clothing and shoe stores such as Bond's, Zachry's, and Hirsch's. Most modern Atlantans would be surprised to see the row of mid-storied buildings and flashy neon signs opposite the Flatiron Building.

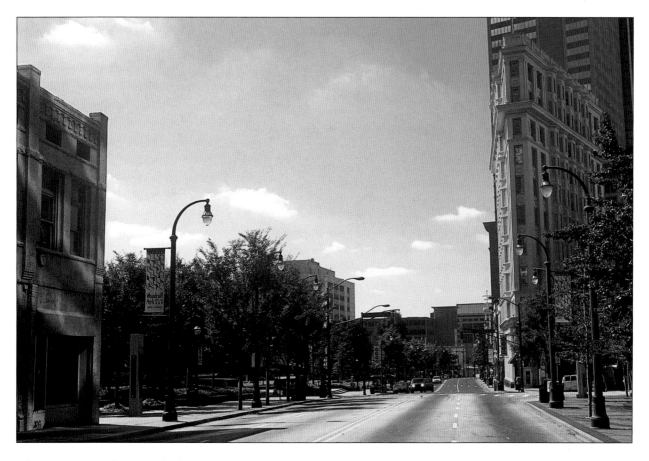

What was an avenue of commerce has been cleared away, presenting
an open green space that has become the heart of the downtown area.
Offering a large, multitiered fountain and numerous benches, Woodruff
Park provides nearby office workers and students with a place to relax
in the sunshine among jazz and rock bands and chess players.

Philanthropist Andrew Carnegie presented Atlanta with this library, his ninth given to an American city. Opening in 1902, the Carnegie Library stood on the corner of Forsyth and Church (now Carnegie Way) streets until it was demolished in the late 1970s. Some of the building's Beaux-Arts columns, frieze, and arches now stand in Hardy Ivy Park at the intersection of Peachtree and West Peachtree streets.

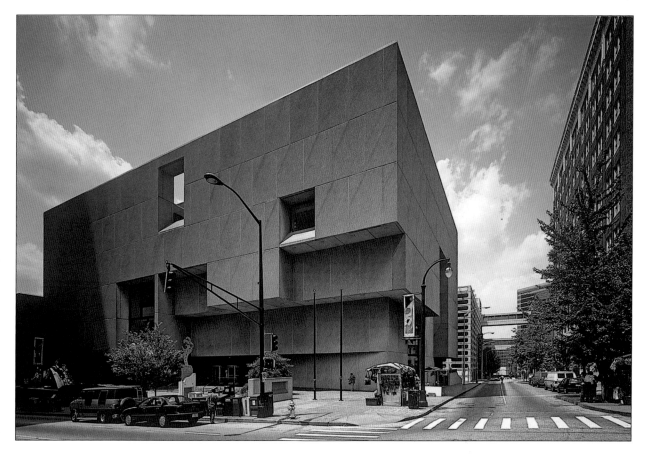

Seventeen years in the making, the Atlanta-Fulton County Public Library opened in 1986, occupying an entire city block on the previous site of the Carnegie Library. Now acting as the central administrative center for a city and countywide system, the library has thirty-five branches serving an estimated 830,000 patrons per year with over 2.7 million publications circulated.

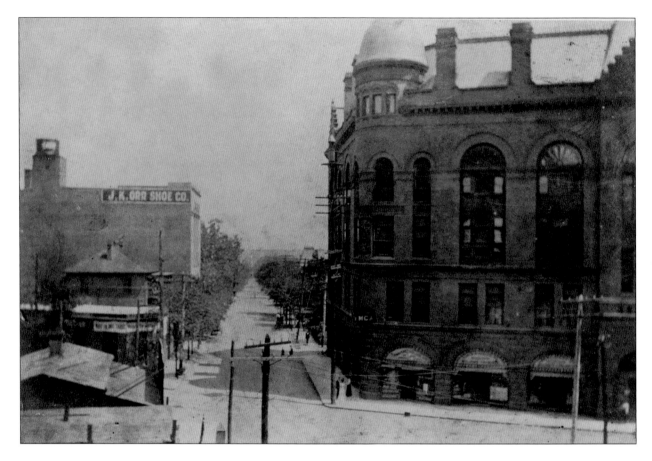

The YMCA Building stands on the corner at right, looking east down tree-lined Wheat Street circa 1890; in 1893 the city changed the street's name to Auburn Avenue. Shortly after the turn of the century, Auburn became the center of African-American business and cultural life in Atlanta. Known as "Sweet Auburn," it was home to businesses and professionals as well as being a social and entertainment district featuring the Peacock Lounge. The street also had a religious focus, with the Wheat Street and Ebenezer Baptist churches and the Big Bethel African Methodist Episcopal Church.

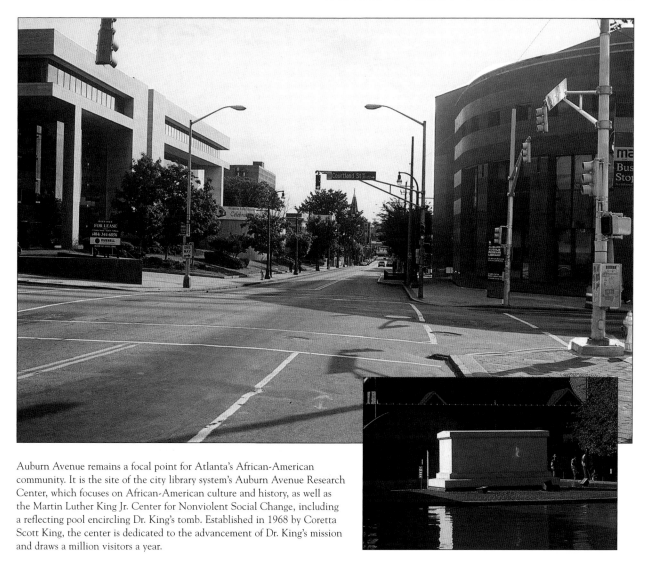

Auburn Avenue remains a focal point for Atlanta's African-American community. It is the site of the city library system's Auburn Avenue Research Center, which focuses on African-American culture and history, as well as the Martin Luther King Jr. Center for Nonviolent Social Change, including a reflecting pool encircling Dr. King's tomb. Established in 1968 by Coretta Scott King, the center is dedicated to the advancement of Dr. King's mission and draws a million visitors a year.

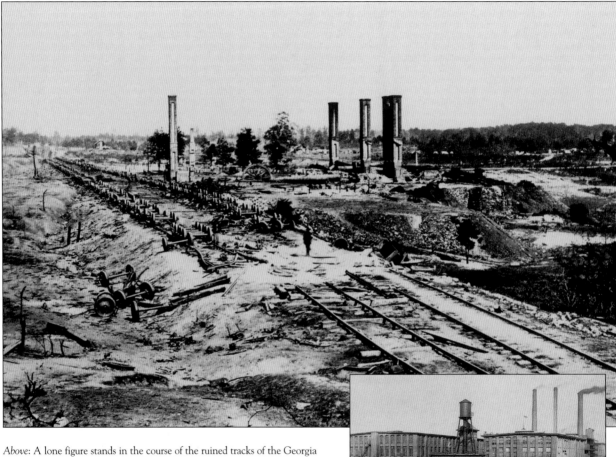

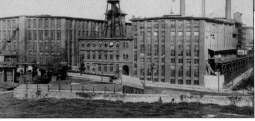

Above: A lone figure stands in the course of the ruined tracks of the Georgia Railroad southeast of downtown: axles and wheels were all that remained of General John B. Hood's ordnance train. Unable to evacuate his munitions prior to the surrender of Atlanta, the Confederate cavalry destroyed them instead—eighty-one rail cars, five locomotives, siege guns, shells, and other material. The resulting explosions burned throughout the night and devastated the Confederate Rolling Mill, whose chimneys appear standing behind the tracks.

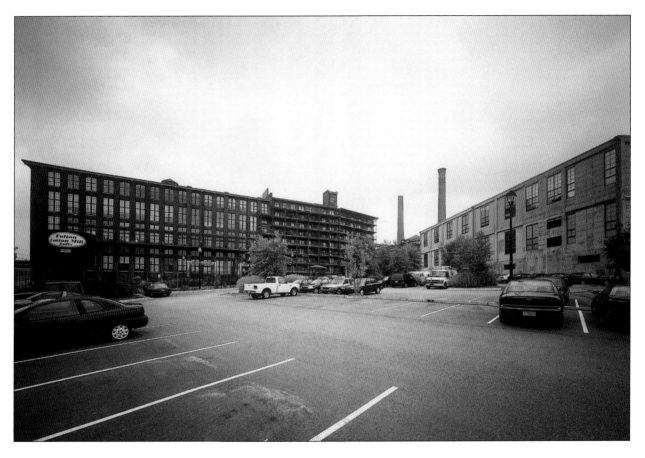

Left and above: In 1881, German immigrant Jacob Elsas established the Fulton Cotton Spinning Company on part of the site where the rolling mill had stood. Once running over 100,000 spindles, the plant closed in the late 1970s and the vast building complex of the Fulton Bag & Cotton Mills, as it had become known, remained empty for nearly twenty years. Undergoing renovation in the spring of 1999, a fire led to a dramatic helicopter rescue witnessed by thousands on live television.

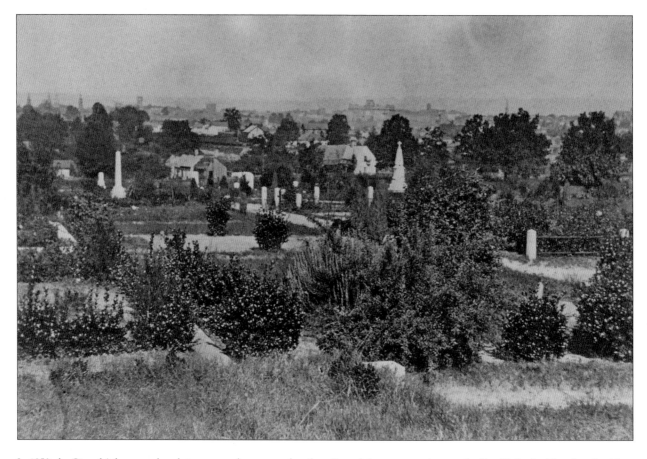

In 1850, the City of Atlanta purchased six acres on the eastern edge of downtown for the creation of a city cemetery named Oakland. Among the chapels, mausoleums, columns, obelisks, pyramids, and Egyptian mastabas, Atlantans had a clear view of downtown, even in the 1880s.

Beyond the graves can be seen the First Methodist Church at far right at present-day Margaret Mitchell Square and, at far left, the cupola of Atlanta City Hall, current site of the Georgia State Capitol.

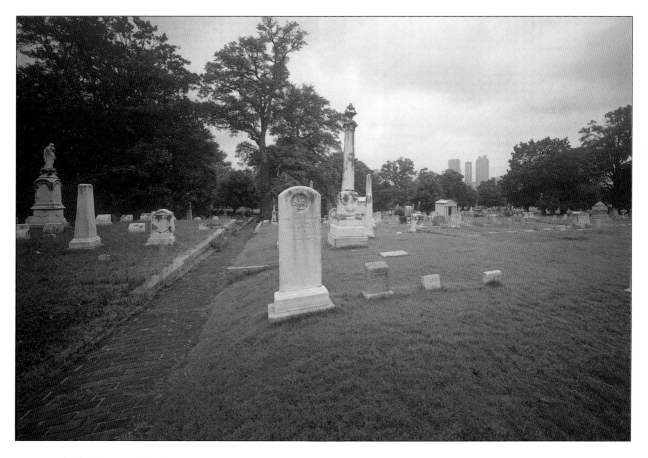

Now encircled by the city, Oakland Cemetery maintains eighty-eight acres serving as a public park for walking, running, or biking. Still owned by the City of Atlanta, it is supported by the efforts of the Historic Oakland Foundation which provides financial assistance and promotes the cemetery's preservation and cultural resources through tours, public events, and restoration efforts.

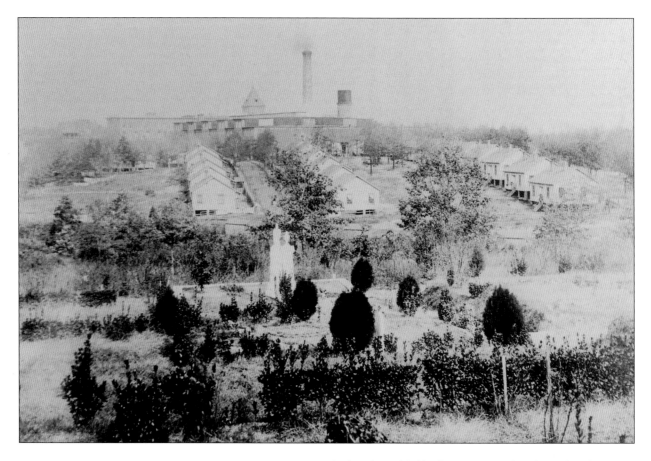

Looking beyond Oakland Cemetery's northern limit, the Fulton Bag & Cotton Mills stands in the distance with the homes of its factory community, Cabbagetown, located between. Contained within a six-block area of narrow streets, the mill-owned houses consisted of duplexes, shotgun houses, and simple cottages filled with rural workers attracted by big-city wages.

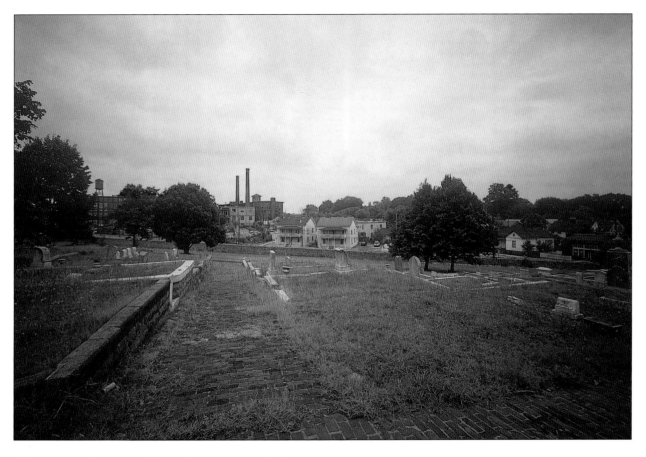

Following the mill's closure in 1977, the Cabbagetown neighborhood steadily declined. Along with recent renovations to the mill site, the community is receiving renewed interest, and inclusion in the city's empowerment zone makes the area attractive for investment. Recently, restaurants and other businesses have begun to locate in the area, and many of the old mill homes are being renovated into homes and offices.

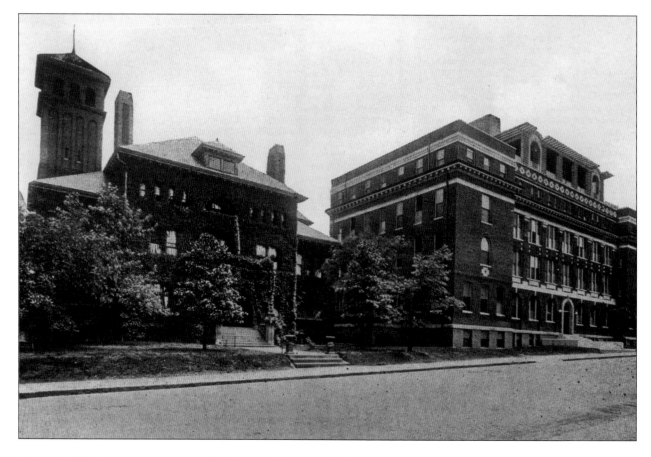

On June 1, 1892, the first patients arrived at Grady Memorial Hospital, the city's first municipal medical facility. Following the death of Henry W. Grady, spokesman of the "New South," in 1889, the city had approved funds for the establishment of a hospital—long advocated by Grady—in his memory. Originally, the Romanesque redbrick building stood on Butler Street in front of a series of connected wards taken down in 1959; the six-story addition pictured here was built in 1904.

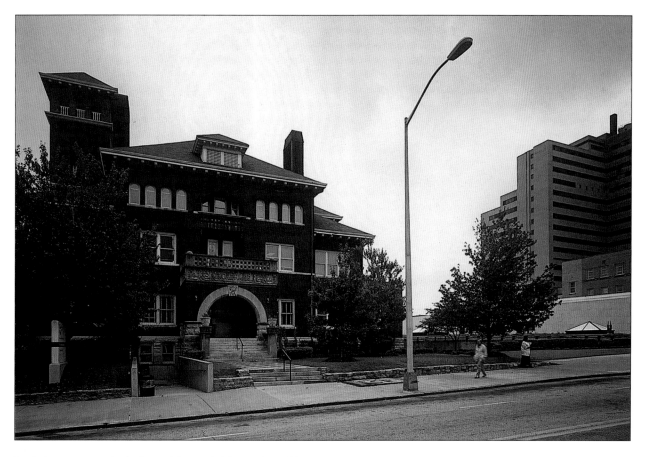

In 1946, management for the hospital (now titled the Grady Health System) was assumed jointly by Fulton and DeKalb counties. The original building is now known as Georgia Hall and houses the system's human resources offices. In the 1950s, a new hospital was built (at right) and, in 1988, a $300 million renovation and expansion to the facility was begun.

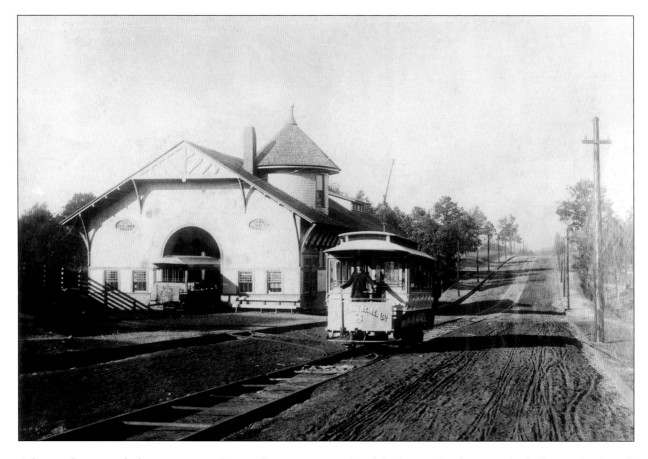

A forecast of progress and urban expansion, an electric trolley car sits outside a shingled streetcar barn at Edgewood Avenue and Elizabeth Street in 1889. The Atlanta and Edgewood Street Railroad Company connected the city's downtown business district with Inman Park, a residential development then being completed. The city's first planned community, the suburb was created by entrepreneur Joel Hurt, who filled it with winding streets, large house lots, and a country park atmosphere—all situated close to the central business district by rail.

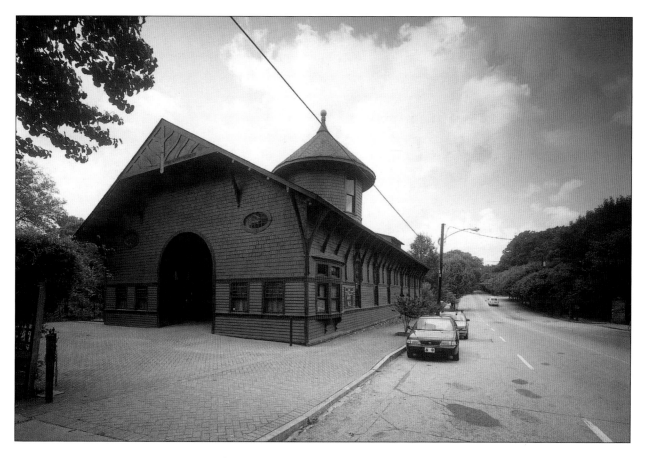

Standing at the terminus of the original Edgewood Avenue line, the
trolley barn served as the repair depot for one of the nation's first
electric streetcar systems. Acquired by the city in 1976, the barn has
been renovated and provides a public facility for the revitalized Inman
Park neighborhood. The building's architecture mirrors the nearly 300
Victorian houses that still fill the neighborhood to this day.

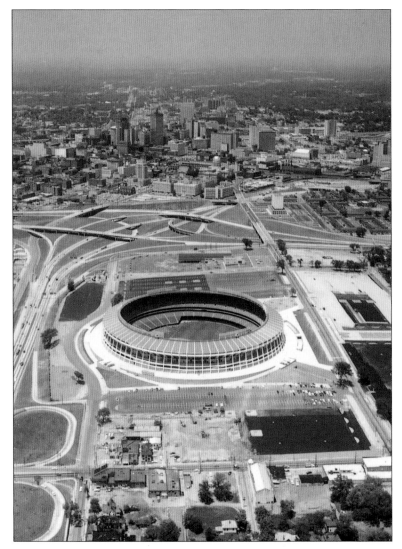

The Atlanta-Fulton County Stadium appears in the foreground of a late-1960s view of the Atlanta skyline. Home to the Atlanta Braves baseball team, the Atlanta Falcons football team, and the Atlanta Chiefs soccer team, the facility opened in 1965—before any professional sports teams were in Atlanta. It was here, on April 8, 1974, that Hank Aaron hit his 715th home run to set a new home run record.

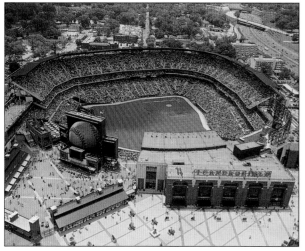

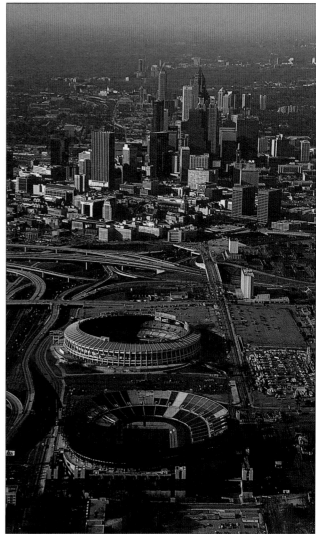

In 1996, an adjacent stadium was built to host the opening and closing ceremonies and the track and field events for the Centennial Olympic Games. In 1997, following service as a venue for Olympic competition, the original stadium was demolished amid protests from the public. Reconfigured for its role as a Major League Baseball arena, Olympic Stadium was rechristened Turner Field in honor of Atlanta Braves owner Ted Turner, founder of CNN. Located on Hank Aaron Drive, the stadium seats nearly 50,000 and features the Ivan Allen Jr. Museum and Hall of Fame, tracing the Braves' history and honoring the mayor who brought the team to Atlanta.

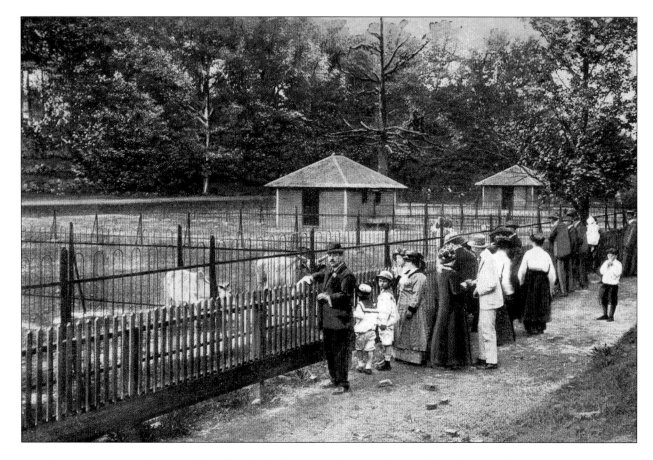

Atlanta's original zoo resulted from the 1889 purchase of a bankrupt circus at auction and the subsequent donation to the city—the purchasers had other intentions for the useful wagons and railroad cars. Situated in Grant Park, the city's zoo was enhanced in 1935 by the donation of its animals from the personal menagerie of Asa G. Candler Jr., son of Coca-Cola's founder, who maintained a private collection of nearly 100 rare birds and over eighty animals, including elephants named Coca and Cola.

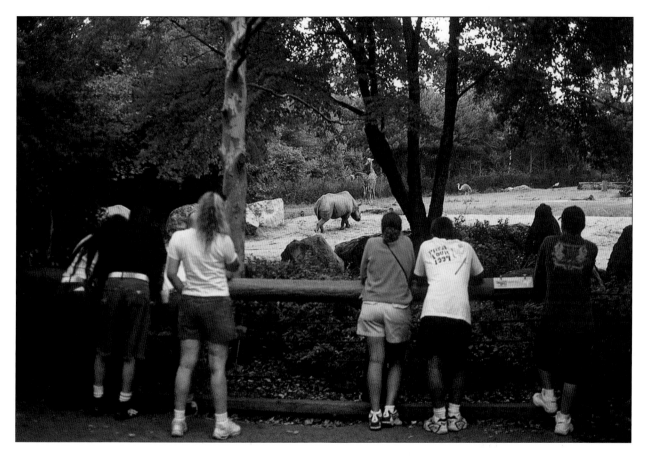

Today, Zoo Atlanta is one of the ten oldest zoos in the country, home to over 1,000 animals, and offers a collection of primates composed of gorillas, orangutans, lemurs, and monkeys. Animals at the zoo are maintained in customary social groupings in open, naturalistic settings, including an African rain forest, Kenyan grassland, Indonesian highland, and Sumatran woodland.

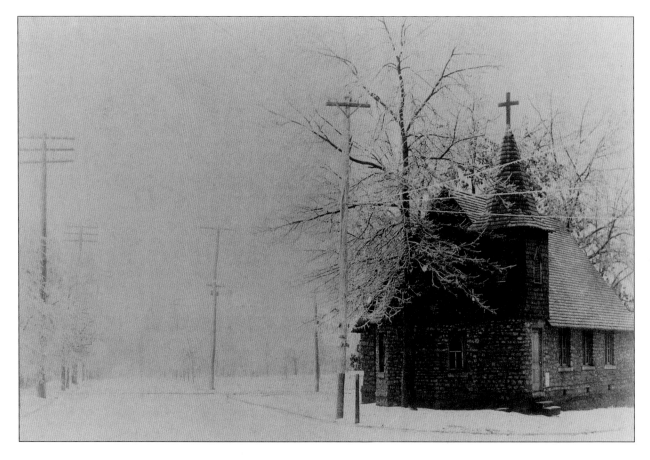

In a wintry, snow-covered landscape, the Church of the Epiphany sits on the triangular-shaped lot created by the intersection of McLendon, Moreland, and Euclid avenues. By the 1920s, the crossroads had become known as Little Five Points and was a flourishing commercial area with three movie theaters, a number of restaurants, and offered shopping to nearby residents in the Inman Park, Edgewood, and Candler Park neighborhoods.

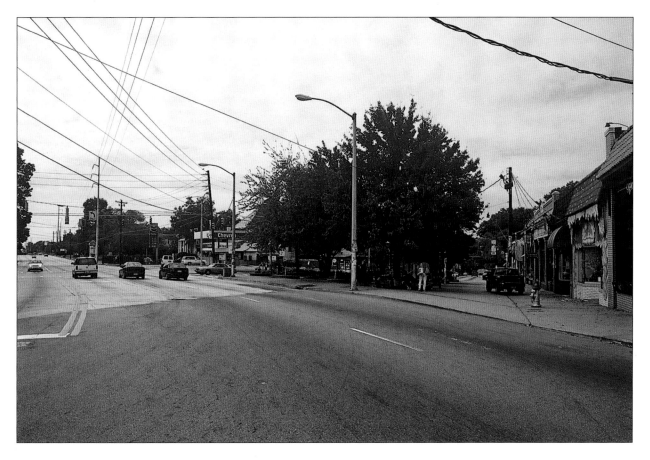

Looking south along Moreland Avenue, the church site is now a park, the original line of Euclid having been closed and turned into a pedestrian walk. Having declined in the 1960s, the neighborhood was revitalized in the mid-1970s when community activists opened new restaurants, bookstores, and pubs as well as saving a number of the area theaters. Today, Little Five Points is an extremely diverse neighborhood, with a thriving culture of art, music, and theater and a social mixture of bikers, hippies, yuppies, and Gen Xers.

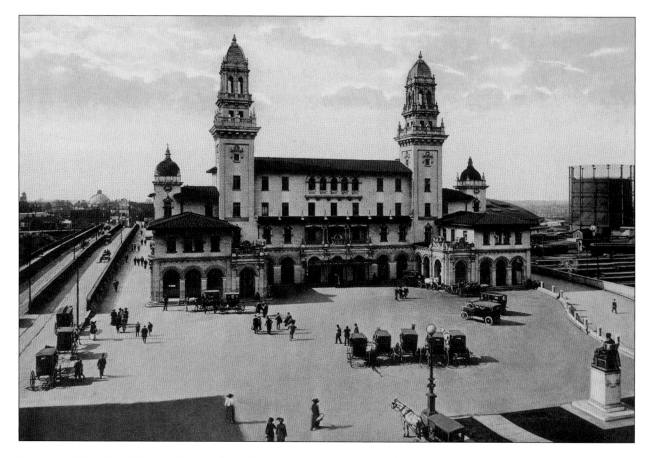

Opening in 1905, Atlanta's Terminal Station replaced the sorely outdated Union Passenger Depot located downtown. Constructed of reinforced concrete, it was a fanciful gateway designed by P. Thornton Marye, the architect of the equally elaborate Fox Theater. Completed at a time when the city's railways were its all-important commercial transportation lines, the station became the victim of automobiles and air travel and was demolished in 1972.

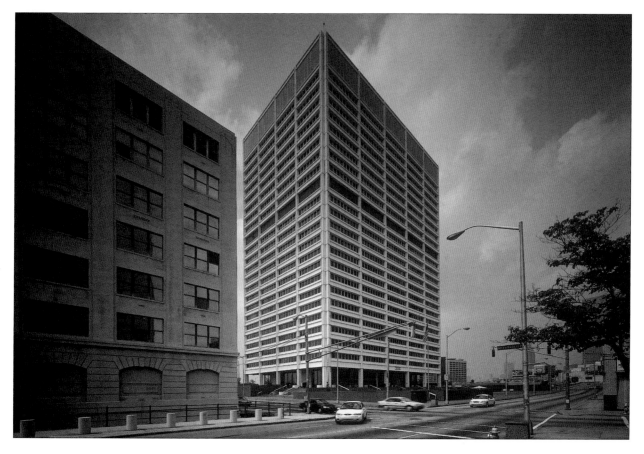

Replacing the rail station at Spring and Mitchell streets, the Richard
B. Russell Federal Building and U.S. Courthouse is named for former
Georgia congressman, governor, and senator Richard B. Russell.
Opening in 1980, the facility consolidated a number of federal court
and government agencies that had been scattered throughout the city.

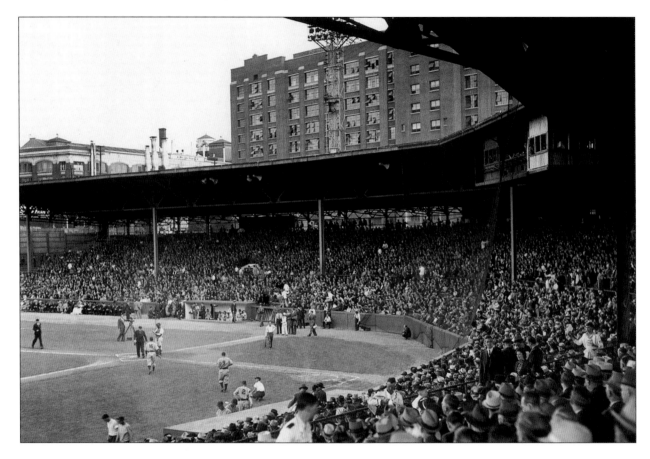

A crowd watches a game at Spiller Field, commonly known as Ponce de Leon Ballpark, in 1940. The field was home to the minor league Atlanta Crackers and occasionally the Atlanta Black Crackers until the mid-1960s, when Atlanta-Fulton County Stadium was built.

Above the stands appears the Sears and Roebuck Building built in 1926 on the site of the Ponce de Leon Springs Park. The building acted both as a retail outlet and a warehouse facility for the company's mail-order business.

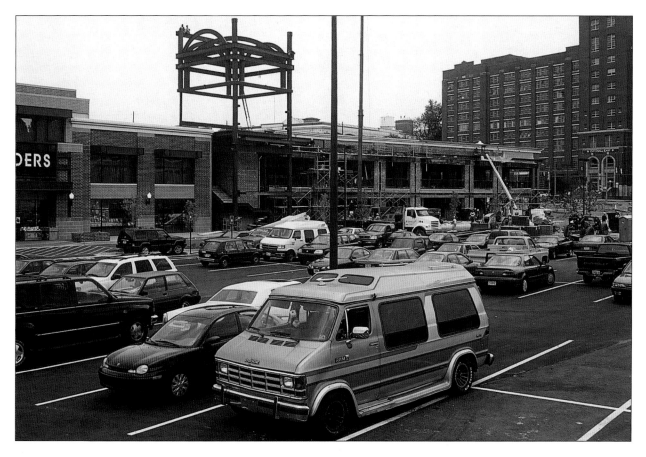

Today, all vestiges of the old stadium are gone, including the great magnolia tree that stood in right field. As a new shopping complex takes shape, the Sears building is now Atlanta's City Hall East, housing offices and galleries for the Bureau of Cultural Affairs, among other city departments. Much of the commercial and residential revitalization of the area is due to an organization known as SHAPE—Shaping Historic Atlanta in the Ponce de Leon Environment.

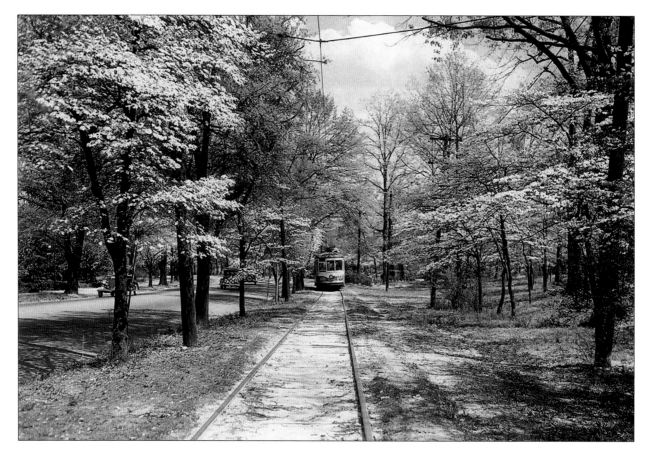

Moving along an alley of dogwood, a trolley car heads east along Ponce de Leon Avenue in the Druid Hills neighborhood in the 1930s. In the 1890s, Atlanta developer Joel Hurt had hired Frederick Law Olmsted, designer of New York's Central Park, to plan the city's "ideal residential suburb." Ponce de Leon acts as a picturesque central parkway along which a series of open vistas and public green spaces appear within the median in a natural, wooded topography.

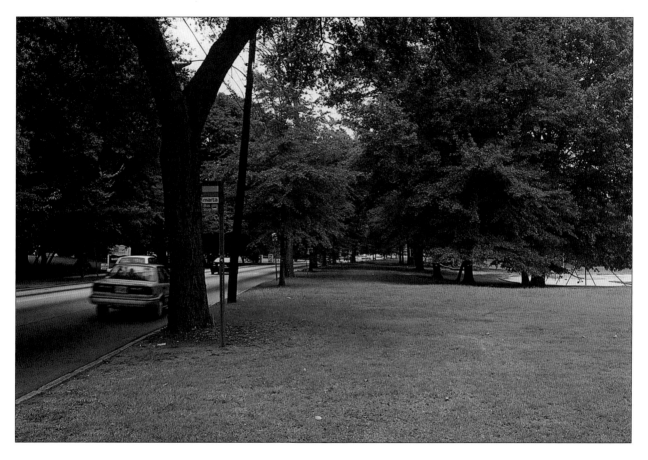

Minus the electric trolley line, Druid Hills has nevertheless preserved Olmsted's innovative vistas, wooded drives, and green spaces, and the 1,300-acre historic district is on the National Register of Historic Places. In addition, Olmsted's design is credited with influencing other Atlanta neighborhoods, including Ansley Park, Avondale Estates, Brookwood Hills, Garden Hills, and Morningside.

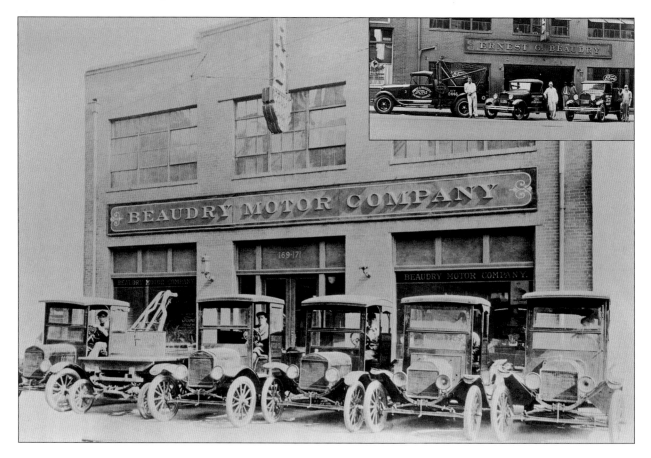

Above: In 1916, Ernest Beaudry opened Atlanta's first Ford dealership on Marietta Street, and within twenty years had sold nearly 32,000 new and used automobiles; in 1983, it was the nation's largest Ford dealership. Beaudry maintained a main showroom and a used car lot as well as his parts and services department located nearby on Walton Street (*inset*).

Right: In the area where the dealership and its service department once stood, visitors now stroll through the water jets of the Fountain of Rings, part of Centennial Olympic Park. Created for the 1996 Olympic Games, the park is twenty-one acres of green space located just northwest of the downtown area and containing plazas, memorials, and foliage in an area once covered by warehouses and parking lots. Behind the park rise the circular Westin Peachtree Plaza and other high-rises running along Peachtree Street.

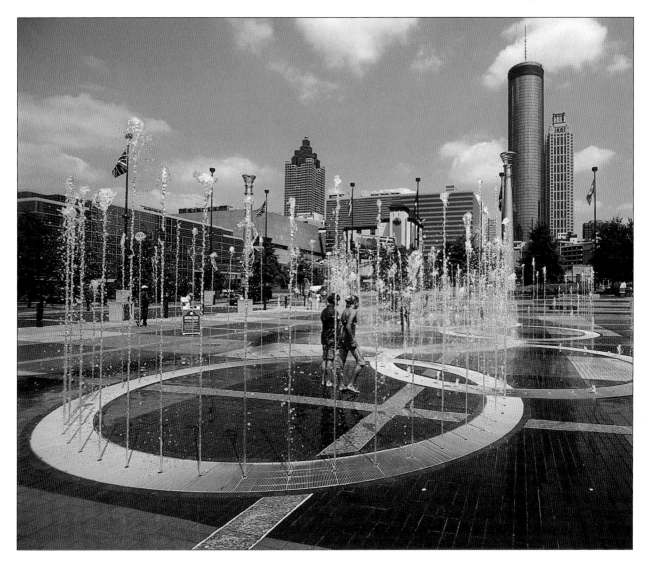

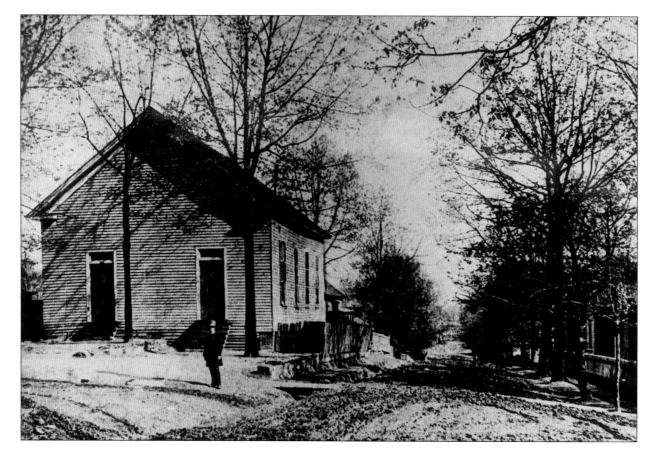

In 1892, Reverend Samuel R. Belk stands before Payne's Chapel, built in 1869 at the intersection of Luckie and Hunnicutt streets. The small Methodist chapel was taken down shortly after this picture was taken and replaced by a brick building named Payne Memorial Church after the chapel's benefactor, Edwin Payne.

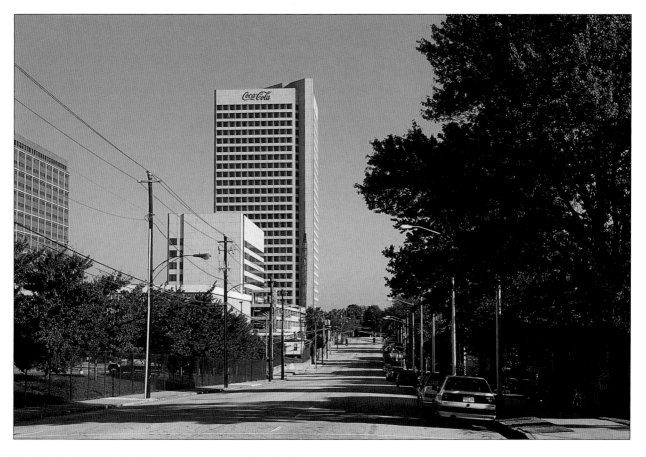

Demolished in 1951, the church's site now serves as a parking lot for the Coca-Cola Company's cluster of corporate buildings adjoining the Georgia Tech campus. Hunnicutt, in fact, is no longer a cross street but now dead-ends at Luckie Street. In the distance is Coca-Cola's North Avenue Tower, built in 1980.

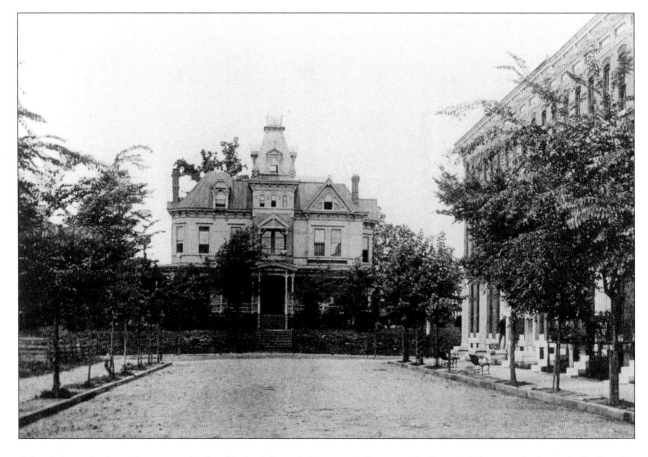

Atlanta's first and only row houses were developed by Jacob Rosenthal in 1886 and later named Baltimore Block for Rosenthal's hometown. Though initially a success, it fell into disuse when commercial establishments encroached on the site. In the 1930s, it became a popular living area for the city's bohemian subcultures. At the far end of the street—initially known as Hunnicutt Avenue—is the residence of the man from whom the property was purchased, Calvin Hunnicutt.

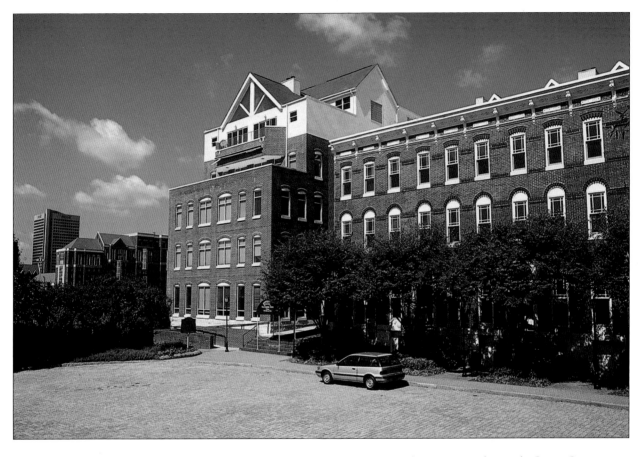

Although the original fourteen units are reduced to ten, the block was renovated in 1989 with additions at the end of the row and a glass roof atrium connecting it to office and apartments behind. Where the Hunnicutt residence once stood is now the I-75/85 downtown connector. Across the interstate can be seen the Georgia State University Village student dorms, originally built as housing for 1996 Olympic athletes, and the Coca-Cola headquarters beyond.

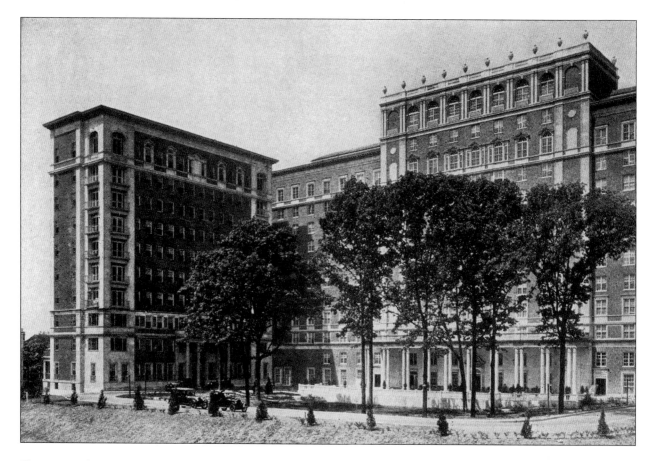

The terrace garden entrance to the Atlanta Biltmore, once known as the South's supreme hotel, was the site of tea dances, debutante balls, and weekly orchestra dinners. In addition, WSB—the South's first radio station—broadcast from studios located on the top floor. Atlanta's early hotels centered on the railroad station and the downtown area. In the twentieth century, they moved north along Peachtree Street into the northern suburbs, represented by the Georgian Terrace (1911) and the Biltmore. Opening in 1924 with backing from William Candler, son of Coca-Cola's founder, the hotel was located on West Peachtree in the prestigious residential area near Peachtree Street and Ponce de Leon Avenue.

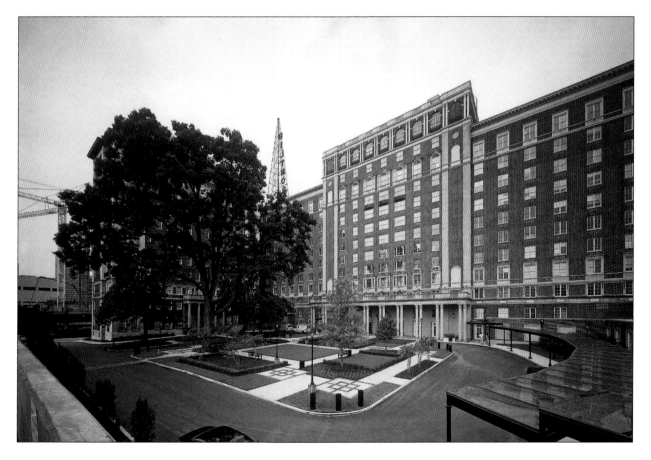

During its prime, the hotel was host to Franklin Roosevelt, Charles Lindbergh, Bette Davis, Mary Pickford, and Dwight Eisenhower. However, despite a 1969 renovation, the hotel closed in 1982 because of competition from modern hotel chains. After sixteen years of neglect, the Biltmore has now been renovated as office, retail, and residential space. The twin towers atop the building spelling out "Biltmore" light up the Atlanta skyline.

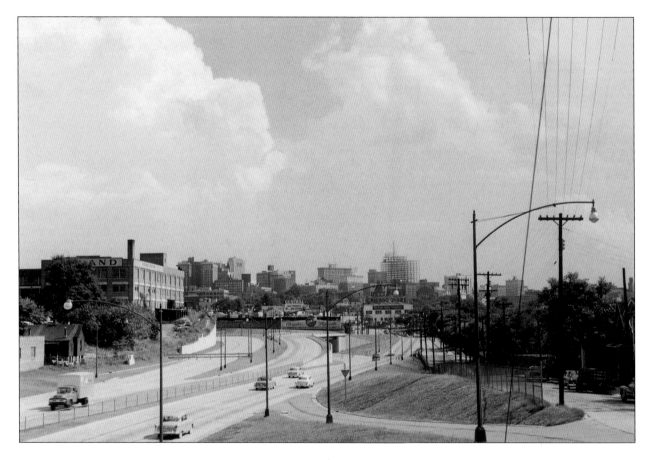

Looking at Atlanta from the north side near the Georgia Tech campus, the skyline in the early 1950s consisted of a few high-rise buildings, including the Candler Building and the Winecoff Hotel. At the Williams Street exit ramp, approaching the city, stands the "Fly Delta Jets" sign familiar to most Atlantans, which stood in this prominent location until 1998.

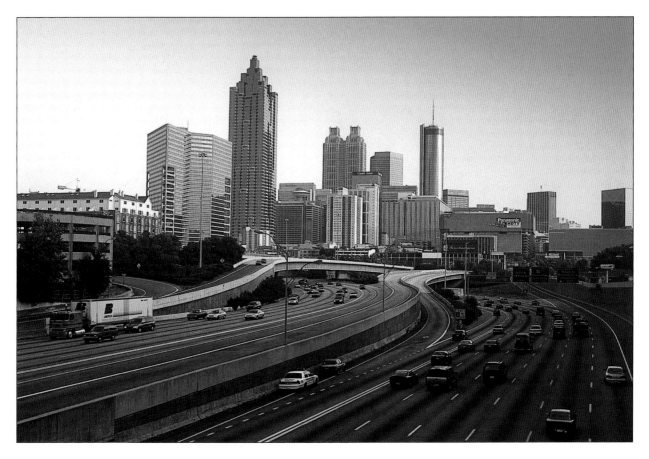

Looking from the same location, the North Avenue Bridge, the identical view today includes the Peachtree Summit building at left, SunTrust Plaza at One Peachtree Tower, the temple-topped 191 Peachtree Tower, and the circular Westin Peachtree Plaza.

Looking at Atlanta from the east in the late 1960s, the stark, black Equitable Building stands at center left; at right is the blue, spaceship-shaped dome of the Hyatt Regency Atlanta. Opening in 1967, the building was the world's first contemporary hotel with an indoor atrium, a design by John Portman that reinvented modern hotel architecture. Another of the building's distinctive features was the blue dome housing a revolving restaurant—the Polaris.

Atlanta's modern skyline rises behind a sea of dead kudzu and highway concrete. The black building that is apparently leaning at far right is the headquarters of the Georgia Power Company. Its curious shape is the result of a design allowing for the total elimination of the sun's rays into the building on the summer solstice. It has also led to it being commonly known as the "Leaning Tower of Power."

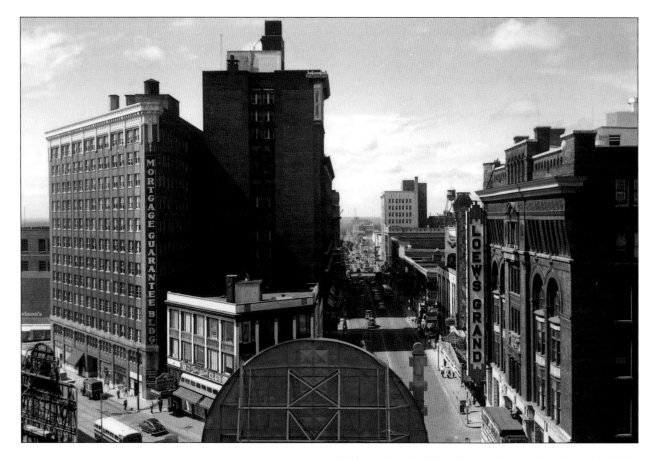

Peachtree Street in 1949, looking north from inside the Candler Building and from behind the circular Coca-Cola sign that once stood at Margaret Mitchell Square. At left stands the Carnegie Building, constructed in 1926; the tall building silhouetted against the sky is the Winecoff Hotel, scene of the nation's deadliest hotel fire on December 7, 1946; Loew's Grand Theater is at right.

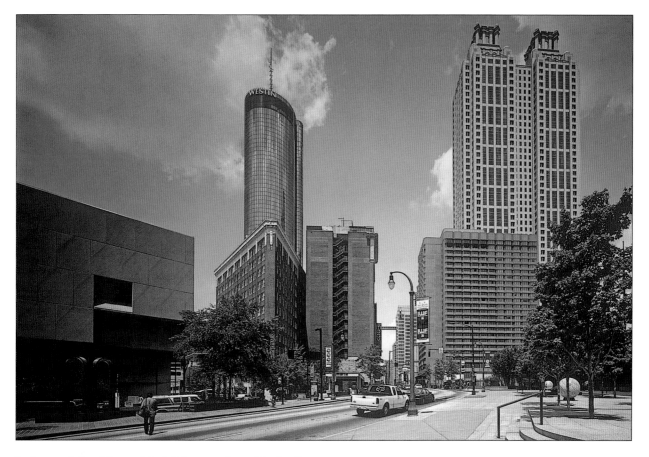

Looking north from Margaret Mitchell Square in front of the Candler Building, the Carnegie and Winecoff buildings remain at center left. The skyline, however, is now dominated by the seventy-story glass cylinder of the Westin Peachtree Plaza built in 1976—the world's tallest hotel—and the pair of temple-topped towers of 191 Peachtree, which was finished in 1990.

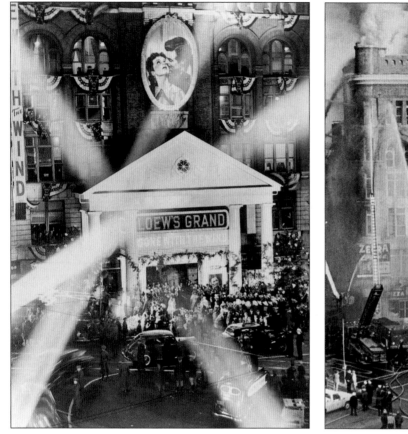

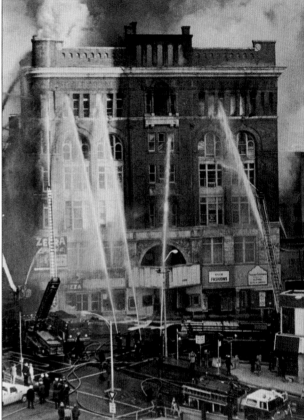

Above left: Loew's Grand Theater, originally constructed as DeGive's Grand Opera House in 1893, wears the facade of the mythical Tara and a majestic cameo of Scarlett O'Hara and Rhett Butler. Following days of celebrations, including a parade and ball in the city's municipal auditorium, the night of December 15, 1939, saw the opening of the film version of Margaret Mitchell's Pulitzer Prize–winning novel, *Gone With the Wind.* Fire destroyed Loew's Grand on January 31, 1978 (*above*).

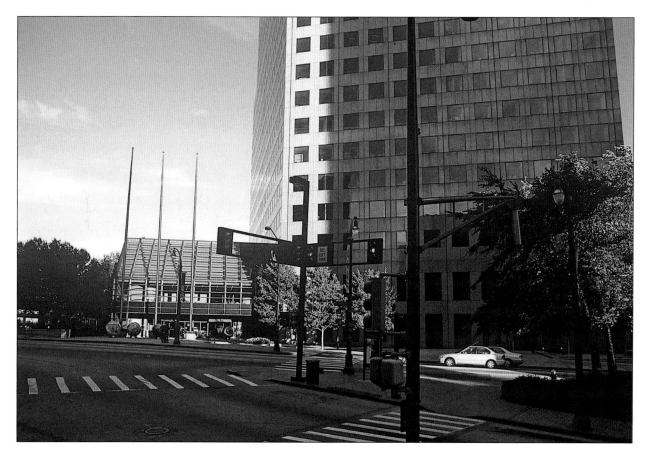

In 1978, the same year as the Loew's fire, Georgia-Pacific moved
its headquarters from Atlanta to Portland, Oregon. Four years later,
the corporation returned to the South and located its distinctive
headquarters building, the Georgia-Pacific Center, at Margaret
Mitchell Square on the site of the theater.

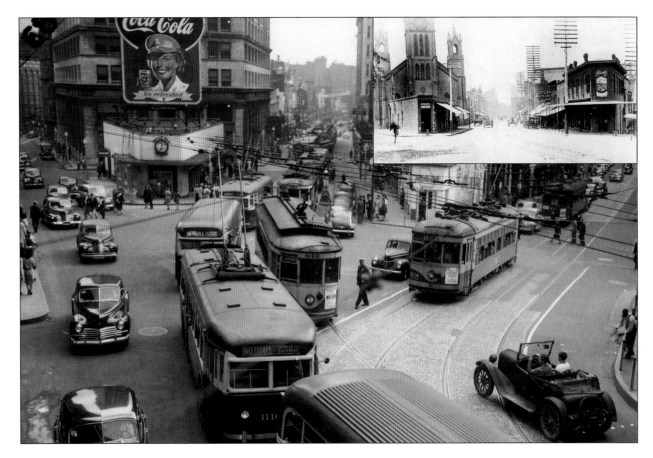

Inset: Looking south along Peachtree Street in the late nineteenth century, the First Methodist Church stands at the intersection of Peachtree and Pryor Streets, its main entrance obscured by a drug store. Sixty years later (*above*), the street, once lined with multitiered telephone poles, is flooded with trolleys and automobiles. The Coca-Cola billboard at the intersection of Peachtree and Pryor streets, later a neon sign, was a city landmark from 1949 until 1981.

Right: The important intersection of Peachtree, Pryor, and Forsyth streets didn't actually obtain the name Margaret Mitchell Square until 1976, almost thirty years after her death. A onetime reporter, Mitchell began working on her book after an ankle injury laid her up at home. Winning her the 1937 Pulitzer Prize, the novel has sold more copies than any book other than the Bible.

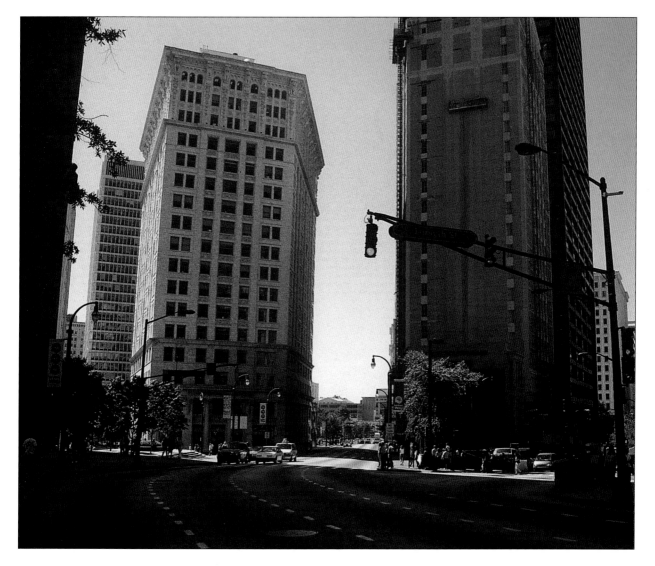

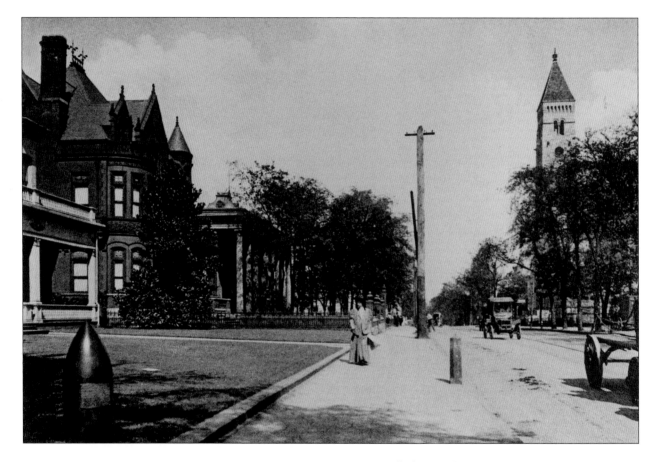

A woman strolls along Peachtree Street in 1905, when it was still a residential avenue of fine homes. The building at left is the first governor's mansion; just beyond, the white multicolumned house is the Herring-Leyden residence, used as Union General George H. Thomas's headquarters during the Federal occupation of Atlanta in 1864. The stone tower at right belongs to the First Baptist Church.

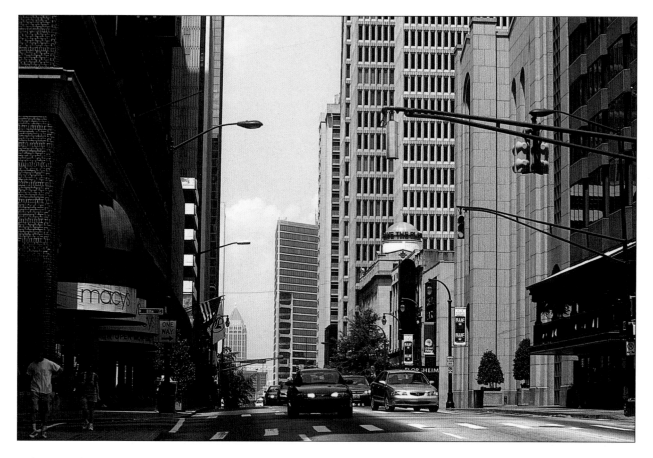

In the twentieth century, this section of Peachtree became the
commercial heart of the city—what most Atlantans think of when
you mention "downtown." Today, it still remains an avenue of luxury
hotels, office towers, restaurants, and the downtown Macy's, located on
the site of General Thomas's headquarters.

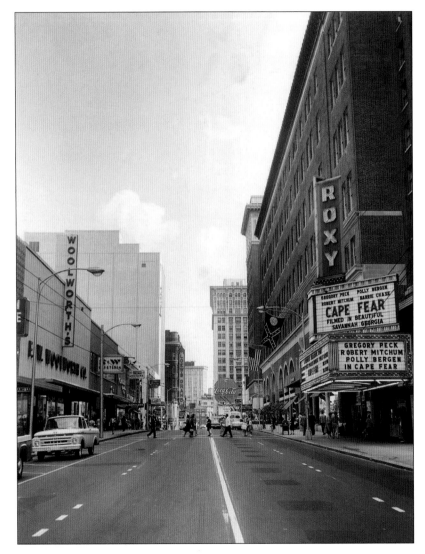

With the Roxy, Loew's Grand, and Paramount theaters clustered together, this length of Peachtree Street was once known as the Theater District. In this view, the Paramount Theater, originally constructed as the Howard Theatre and designed by Hentz, Reid, and Adler, had already been demolished in 1960. The building at right is Davison's department store, designed by Atlanta classical architect Philip T. Shutze.

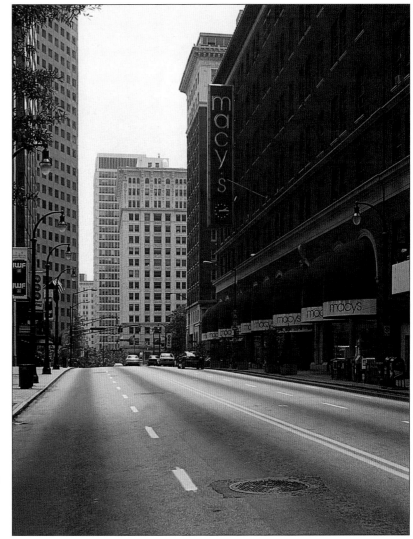

Located on the most prominent point of the Peachtree Ridge at 1,000 feet above sea level, Atlanta ranks as the highest city east of the Mississippi River. The street at this point actually marks the geographic divide from either side of the street—water running from the east side of Peachtree Street flows down to the Atlantic Ocean; water running from the west side of the street flows into the Gulf of Mexico.

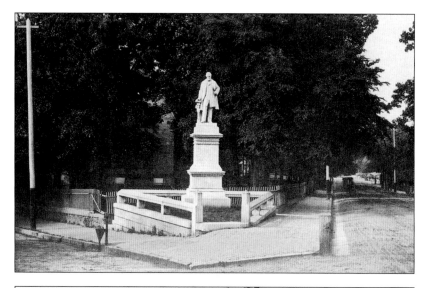

Left: At Baker Street, the north end of the downtown Peachtree corridor, Peachtree Street veers suddenly to the right, and West Peachtree continues straight ahead. Originally, Peachtree itself continued and the street to the right was called Oak Street. In the mid-1870s, this designation changed—Oak became Peachtree and West Peachtree was created. The statue in the park is dedicated to Benjamin H. Hill, congressman and senator from Georgia. By the mid-twentieth century, the small park had been completely commercialized with a service station (below left).

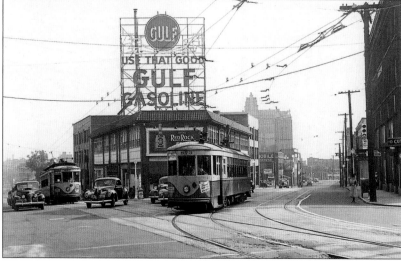

Right: In 1996, architectural elements of the Carnegie Library that once stood at Margaret Mitchell Square were assembled into an archway at Hardy Ivy Park. At the far end of the park sits the statue of Samuel Spencer, president of Southern Railway, which once stood in front of Terminal Station, another demolished public building. Just behind the arch is the Peachtree Summit building (1975); through the arch (inset) can be seen One Atlantic Center, commonly known as IBM Tower (1987).

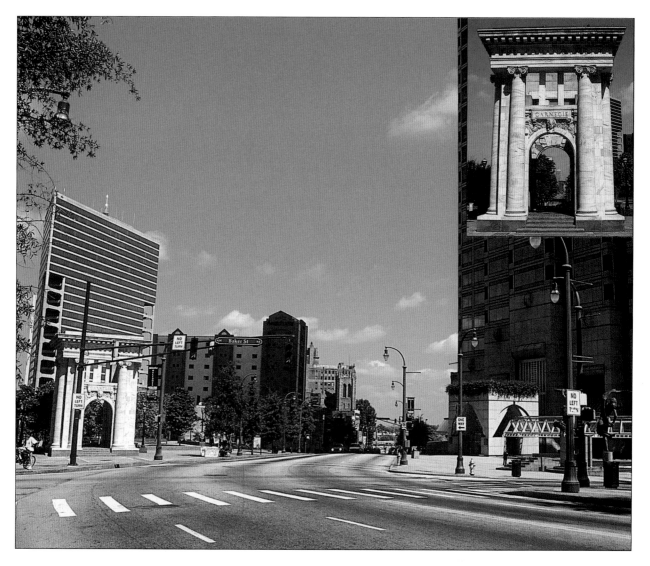

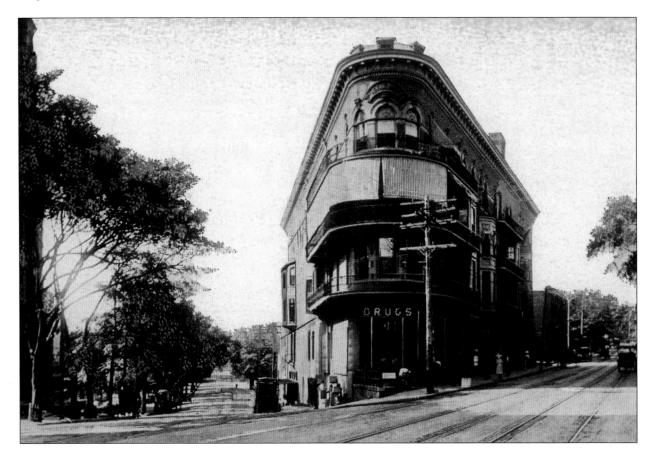

Looking south, the Church of the Sacred Heart of Jesus appears at left along Ivy Street, while the trolley line down Peachtree Street rises on the right. Built in 1898 for the Marist Society of Georgia, the redbrick and terra-cotta church was designed by prominent Atlanta architect Walter T. Downing in a combination Gothic-Romanesque style for the religious and educational needs of the Catholic parish.

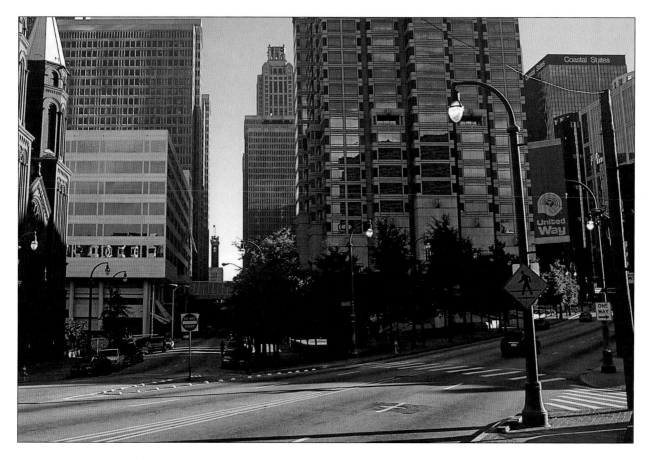

SunTrust Plaza Tower, a sixty-story office building erected by John Portman in 1992, now dominates the intersection. Hardy Ivy was the first permanent white settler in what later became downtown Atlanta, building a cabin on high ground located just southeast of here. In 1984, the street named for him was changed to Peachtree Center Avenue at Portman's request.

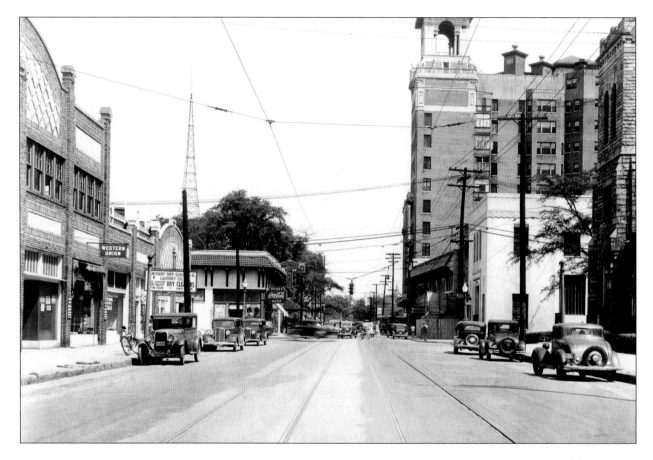

Peachtree Street in the 1930s, looking north toward the North Avenue intersection. At the immediate right is the stone tower of the North Avenue Presbyterian Church, built in 1901, and beyond it one of the temple-topped corners of the Ponce de Leon Apartments. During this period, this neighborhood was one of the most fashionable in Atlanta.

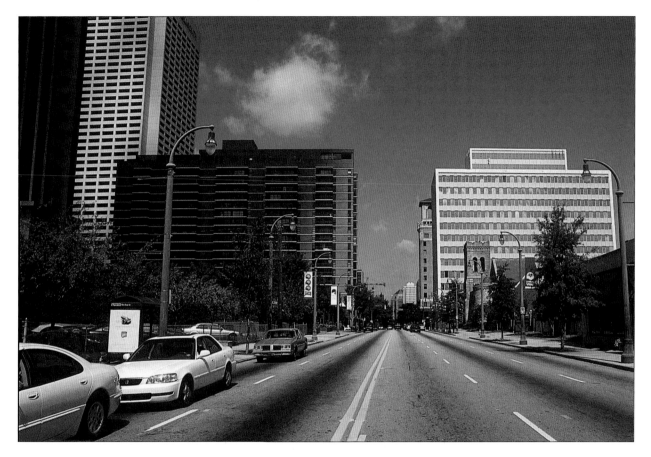

At right, the Presbyterian church tower stands against the Wachovia
Bank of Georgia Building, the Ponce de Leon Apartments' temple
visible just beyond. The open plaza at left is the entrance to the Bank
of America's office tower, the South's tallest building. During the Civil
War, the northernmost outpost of the city's defense works was located
just up Peachtree Street from here.

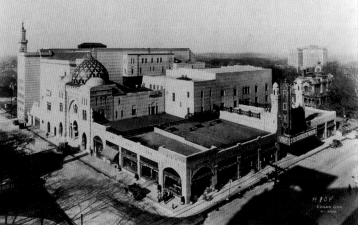

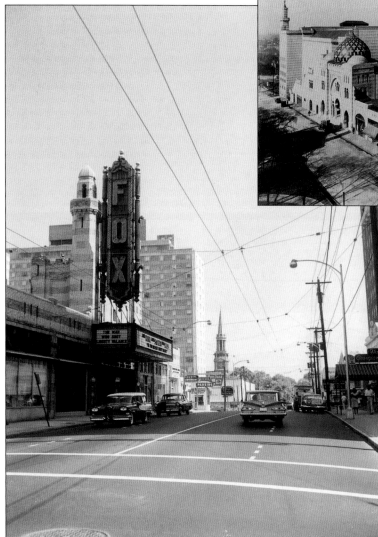

Above and left: Originally designed as headquarters of the 5,000-member Shriner's organization, the Yaarab Temple of the Mystic Shrine was designed in Middle Eastern Revival style by Atlanta architect P. Thornton Marye, who designed the city's Spanish-influenced Terminal Station. The building plans were expanded to include a 4,000-seat movie theater—the Fox—which opened on Christmas Day 1929. The building's lavish interior includes an Arabian courtyard with a twinkling, star-filled sky, canopy-covered balconies, and ballrooms—everything ornately decorated with Moorish-influenced designs. The steeple of the Peachtree Road Baptist Church rises behind the Fox.

Right: Unlike Thornton's Terminal Station, demolished in 1972, the "Fabulous Fox" was saved from destruction through a grassroots effort by the nonprofit group Atlanta Landmarks. Running a four-year "Save the Fox" campaign in the early 1970s, the organization rescued the building and continues to run and restore the theater. The First Baptist Church was demolished in 1999.

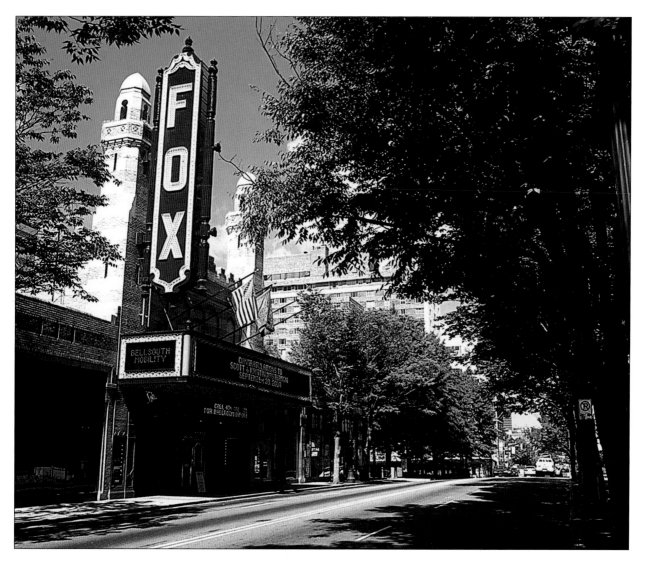

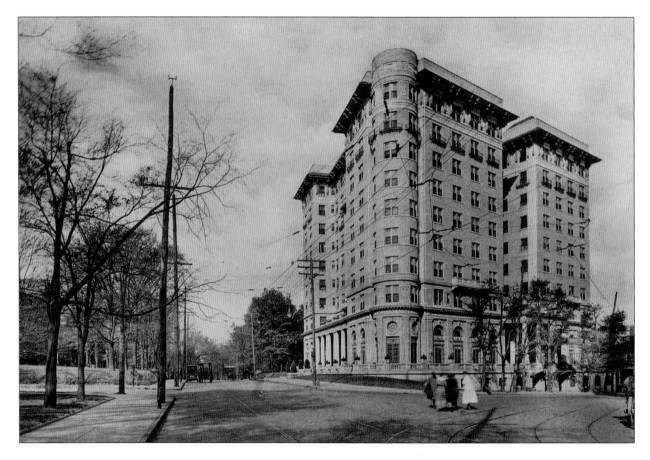

Completed in 1911, the Georgian Terrace remained for many years the finest hotel in the city—in 1939, the stars and celebrities who came to Atlanta for the premiere of *Gone With the Wind* stayed here and celebrated in the Grand Ballroom (Clark Gable was in room 918).

Located on the northeast corner of Peachtree Street and Ponce de Leon Avenue, the Georgian Terrace virtually wraps around the corner on which it sits, effectively facing both of these major streets.

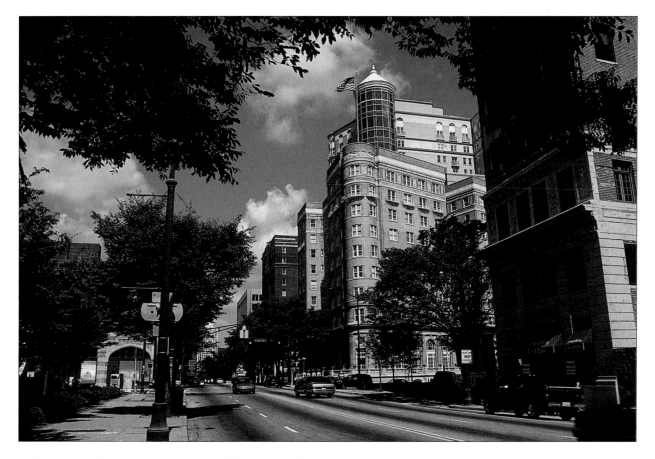

At the time it was built, the hotel was considered the height of fashion and in fact represented the northernmost extension of the city. After closing in 1981, the Georgian Terrace reopened in 1991 as apartments with the notable addition of a modern building echoing the original's distinctive rounded corner. The two structures are connected by an open atrium.

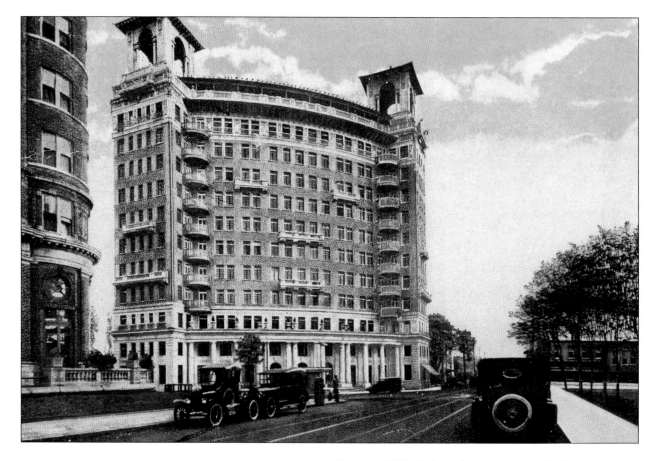

Opening in 1913, the Ponce de Leon Apartment Building was one of Atlanta's first luxury high-rise residential buildings, sitting across Ponce de Leon Avenue from the Georgian Terrrace hotel and designed by the same architect, William L. Stoddart. Unlike the hotel, which wraps around the street corner, the "Ponce," as it is known, faces the intersection with Peachtree Street, curving toward the intersection.

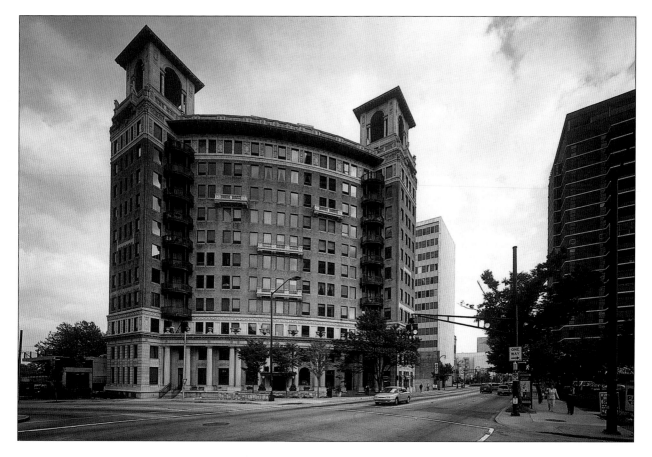

During the 1960s and 1970s, as prosperity and development moved further north along Peachtree Street, fewer Atlantans lived in the downtown area. Ultimately, the Ponce's grand apartments were subdivided into smaller units to provide for a more modest clientele. In 1981, renovations began to convert the building to condominiums.

Left: Photographed in the mid-1960s, this modest building was home for seven years to Margaret Mitchell, author of the world's best-selling novel, *Gone With the Wind*. Built on Peachtree Street by Cornelius J. Sheehan in 1899, the house was divided into apartments twenty years later. This view shows the back of the house along Crescent Street where Mitchell, known as Peggy, lived with her husband John Marsh in basement apartment number 1. She referred to the building as "the Dump."

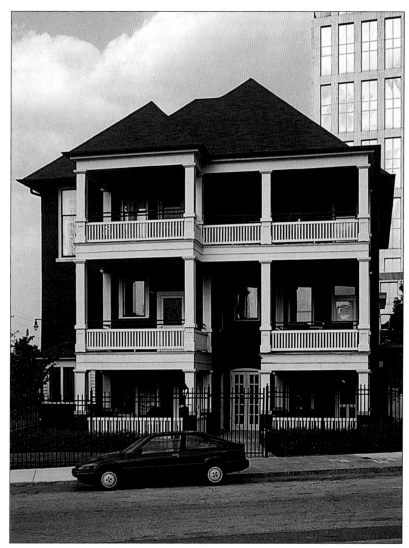

Right: Standing in the heart of Midtown Atlanta at Peachtree and Tenth Street, the Margaret Mitchell House was restored in 1996 with support from Daimler-Benz. The building offers tours, a visitors' center, and exhibitions in an adjacent museum.

Below: From the Margaret Mitchell House, Peachtree Street slowly rises to a height once topped by Hillcrest, the grand home of the Murphy family. When the area was residential, this was one of the finest homes on the street; white-columned and set well back from Peachtree, its veranda offered a wonderful view and a country atmosphere.

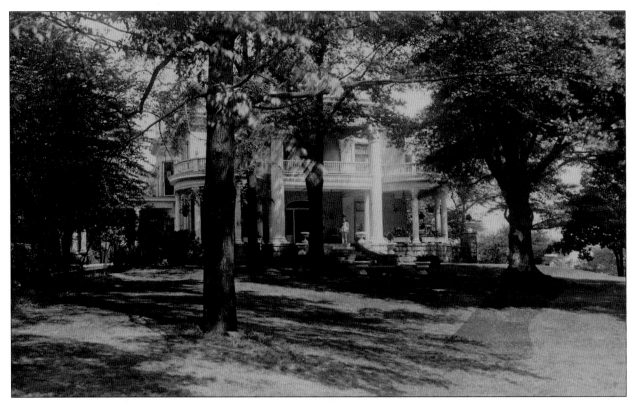

Right: Built in 1969, Colony Square was the South's first multiuse project, offering hotel, office, residential, and entertainment in one complex. As the first high-rise development in the Midtown area, it preceded a building boom that has continued through to today. Midtown is now home to a number of office towers, apartment buildings, and condominiums located along or near Peachtree Street and close to nearby Piedmont Park.

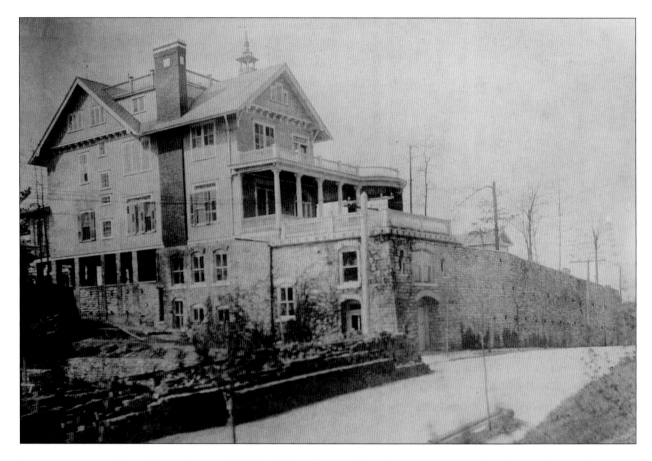

Perched on a crest on Fifteenth Street, Ferdinand McMillan built his unconventional retirement home in 1910, christening it "Fort Peace." Even at the time, contemporaries noted the house for its eccentricity— McMillan acted as his own architect—with features such as the two- story Stone Mountain granite base (complete with "cannon" openings), a Chinese turret, and niches that once held rabbits dedicated to his friend Joel Chandler Harris, author of the *Uncle Remus* stories.

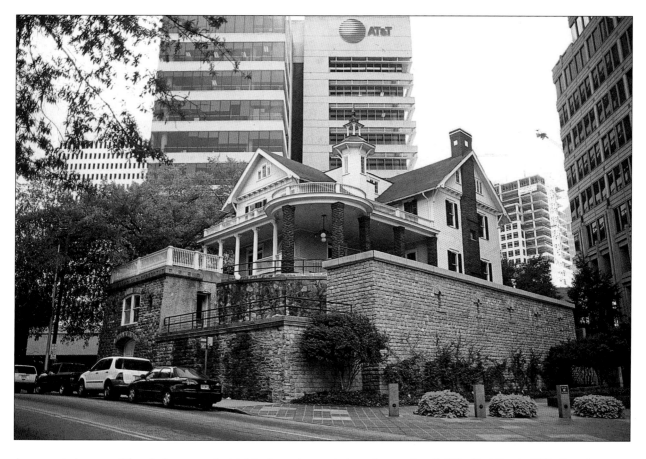

A preservationist cause célèbre, the house was scheduled for destruction in the late 1980s when it was referred to as "a hunk of junk" by the city's mayor, Andrew Young. Ultimately saved, it is now backed by the buildings designed to replace it. Linked to the city's arts community, the house began to be called "the Castle" in the 1950s. Over the years it housed organizations for local theater, music writers, and other arts organizations as well as renting rooms to individual artists. Fittingly, it now overlooks the Woodruff Arts Center.

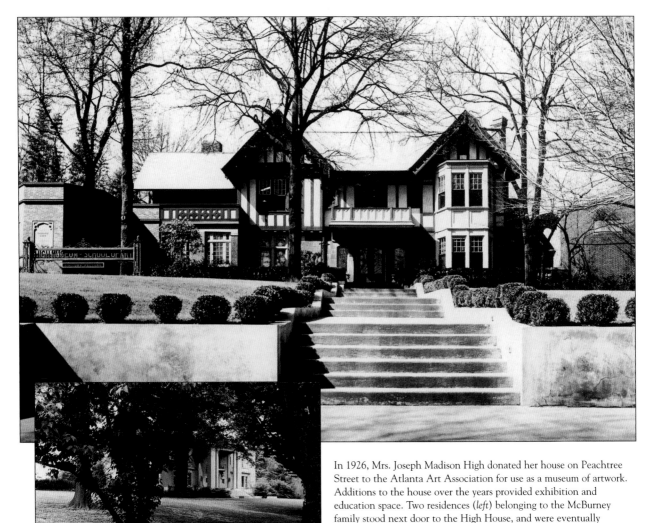

In 1926, Mrs. Joseph Madison High donated her house on Peachtree Street to the Atlanta Art Association for use as a museum of artwork. Additions to the house over the years provided exhibition and education space. Two residences (*left*) belonging to the McBurney family stood next door to the High House, and were eventually annexed to the property.

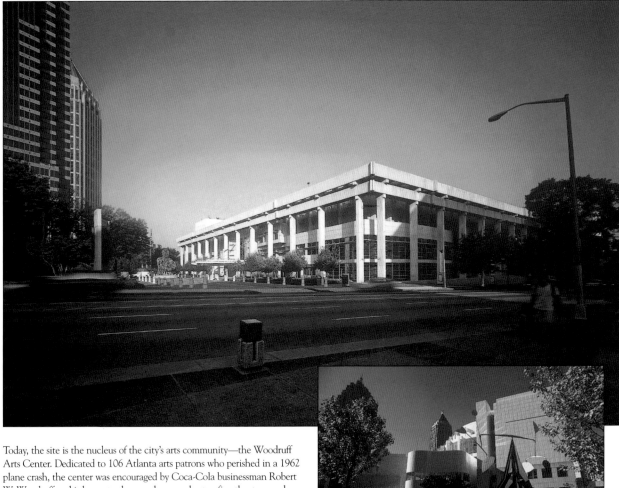

Today, the site is the nucleus of the city's arts community—the Woodruff Arts Center. Dedicated to 106 Atlanta arts patrons who perished in a 1962 plane crash, the center was encouraged by Coca-Cola businessman Robert W. Woodruff and is home to the symphony orchestra, five theaters, and a college of art. The current High Museum of Art (*right*), designed by architect Richard Meier and completed in 1983, is actually located on the site of the McBurney residences, not the High House.

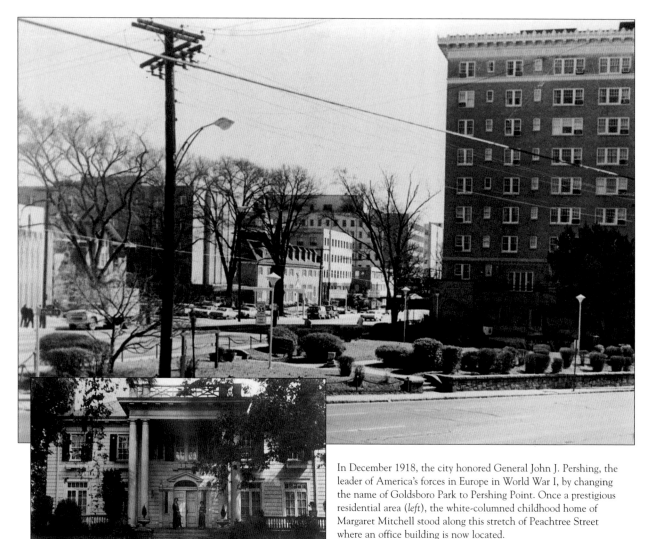

In December 1918, the city honored General John J. Pershing, the leader of America's forces in Europe in World War I, by changing the name of Goldsboro Park to Pershing Point. Once a prestigious residential area (*left*), the white-columned childhood home of Margaret Mitchell stood along this stretch of Peachtree Street where an office building is now located.

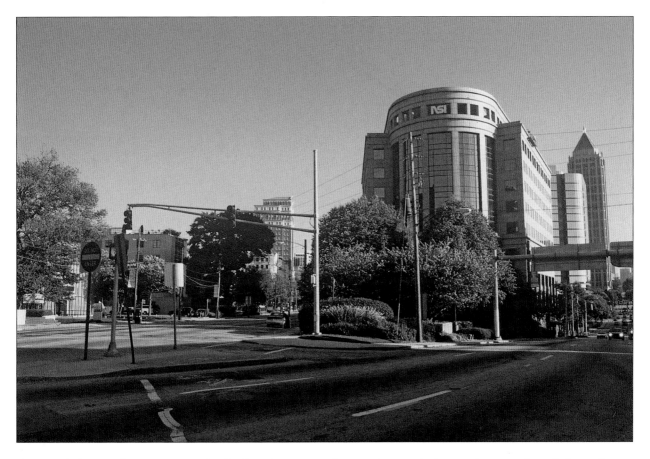

The triangular lot at Pershing Point is situated at the place where Midtown ends—where Peachtree and West Peachtree streets rejoin nearly twenty-five blocks north of the intersection where they separate at Hardy Ivy Park in downtown Atlanta. During the 1920s, the Pershing Point area became a lively community center. Located adjacent the Ansley Park residential area, it offered nearby movie theaters, shopping, and dining to the neighborhood.

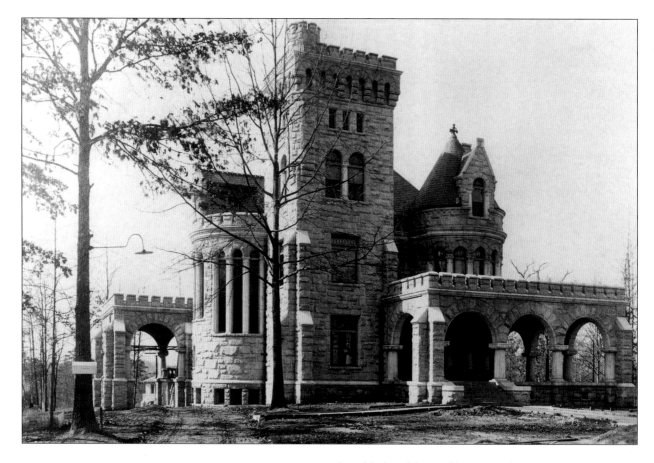

One of the last of the grand homes once lining Peachtree Street, Rhodes Hall was built in 1904 for Amos Giles Rhodes in Victorian Romanesque Revival style out of Stone Mountain granite. Inspired by a European trip in the late 1890s, Rhodes originally named the house "La Rêve" and situated it on a 114-acre estate spreading north across Peachtree Creek.

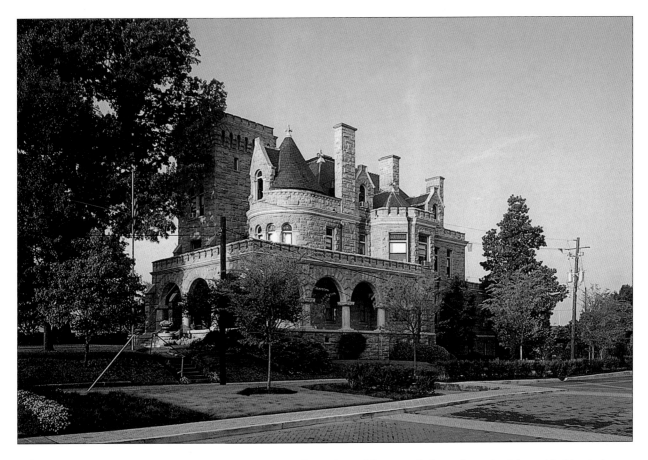

Built when Peachtree was still the first-class residential avenue, within a few years the hall was separated from nearby residential housing, such as Ansley Park, by commercial development along Peachtree. Following Rhodes's death in 1928, his family deeded the house to the State of Georgia with the condition that it be used for historical purposes. For thirty-five years it served as the Georgia State Archives. Since 1983, it has housed the headquarters of the Georgia Trust for Historic Preservation.

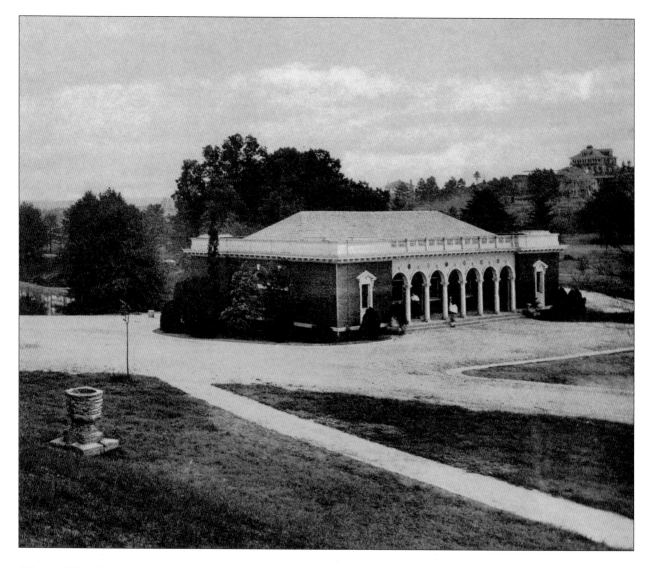

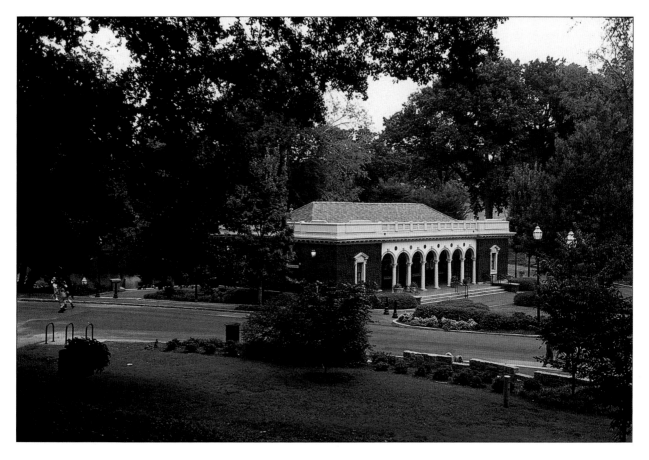

Left: Atlanta's largest public park, Piedmont Park was the site of the Cotton States and International Exposition, and much of the park's landscaping and structures date from that event. Attracting a million visitors from September to December 1895, the exposition was part of the New South's attempt to establish itself as a cultural and economic force. The park property was acquired by the city in 1904, and in 1910 they began making improvements to the park based upon ideas outlined by Frederick Law Olmsted in 1895.

Above: Built in 1911 as a ladies' comfort station, the neo-Renaissance pavilion at the Twelfth Street entrance to the park also served as a boat house for the adjacent park lake, Clara Meer. Renovated in 1998, the building now serves as a visitors' center.

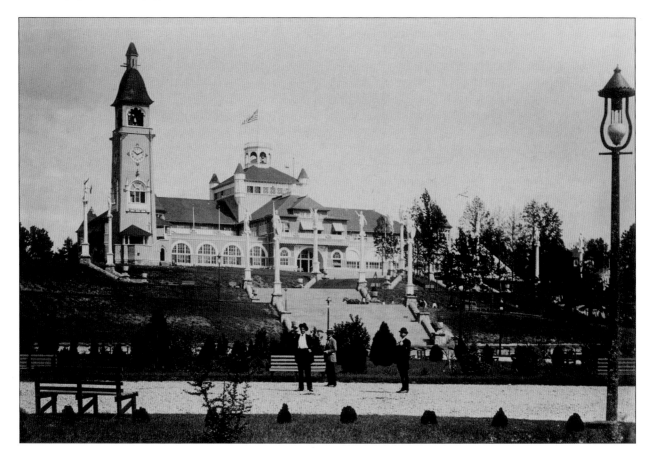

Devised as a means to promote Atlanta and the concept of the "New South," the 1895 Cotton States and International Exposition seen here served as a world's fair. With exhibition halls dedicated to transportation, machinery, agriculture, and manufacturing, the fair demonstrated the progress the South had made since the Civil War and Reconstruction, as well as Atlanta's importance as the center of the developing Southern market.

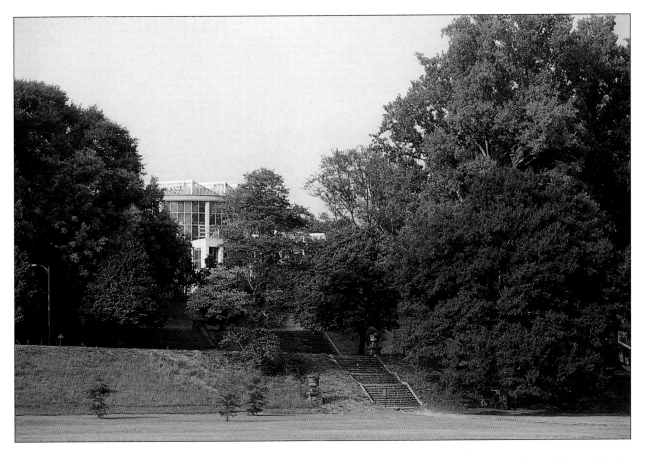

Portions of the original terraced steps and large stonework planting pots remain from the exposition. The site of the exposition's Government Building is now the Dorothy Chapman Fuqua Conservatory, part of the Atlanta Botanical Gardens. Completed in 1989, the conservatory houses rare and endangered plants, displaying them in tropical and desert climates, and fosters education in ecology, conservation, and plant diversity.

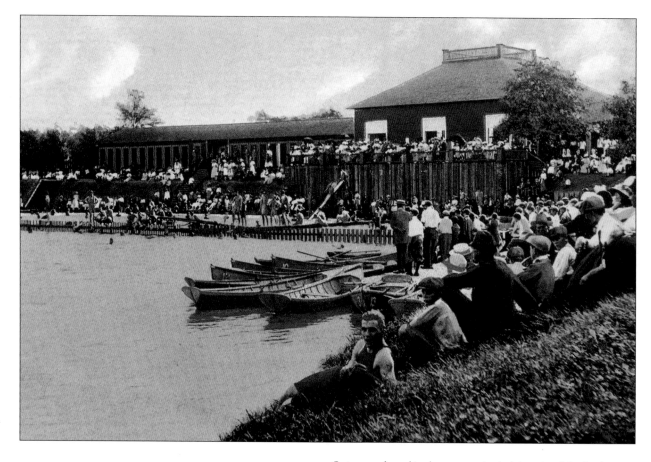

Swimmers, dressed in the conservative bathing suits of the day, lounge around the grounds of the lake and bathhouse in Piedmont Park. For decades, the pool was a crowded and noisy place, as it offered one of the relatively few places Atlantans could take a swim during the heat and humidity of summer.

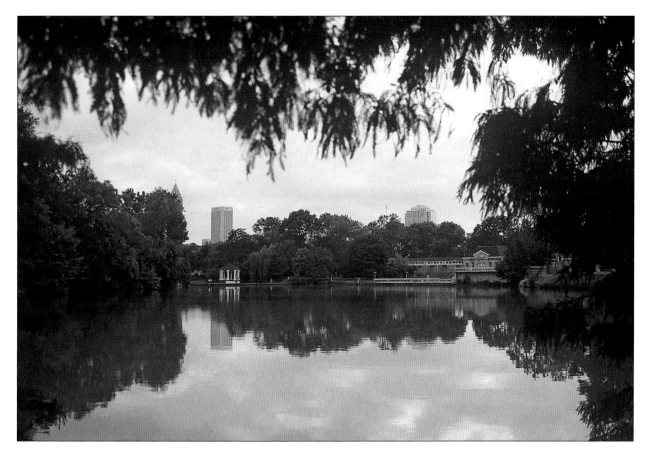

In 1923, the old building was replaced with the current stone bathhouse and a modern pool. With the advent of air-conditioning as well as neighborhood and private pools, use of the pool is not as great as it once was. Beyond the lake and bathhouse rise the modern towers of Midtown.

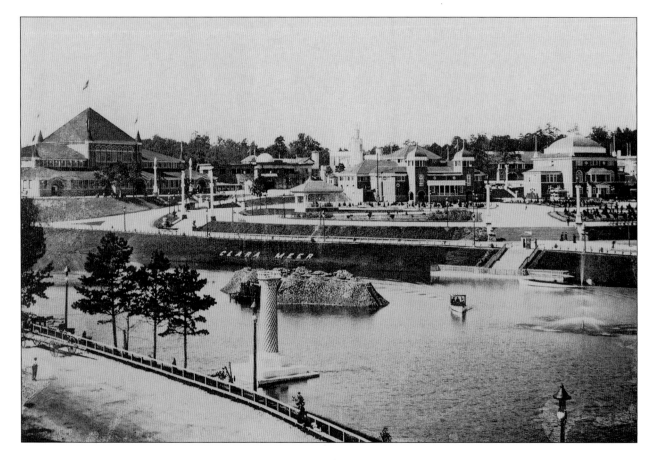

Constructed exclusively for the 1895 Cotton States and International Exposition, the temporary buildings surrounding Clara Meer were dedicated to a variety of states—mostly Southern, although they included halls for New York and Massachusetts—and the buildings were designed to promote Southern business as well. In addition to the buildings, the exposition featured a midway, amphitheater, and a number of entertainment venues, including the nation's first motion picture display and Buffalo Bill's Wild West Show.

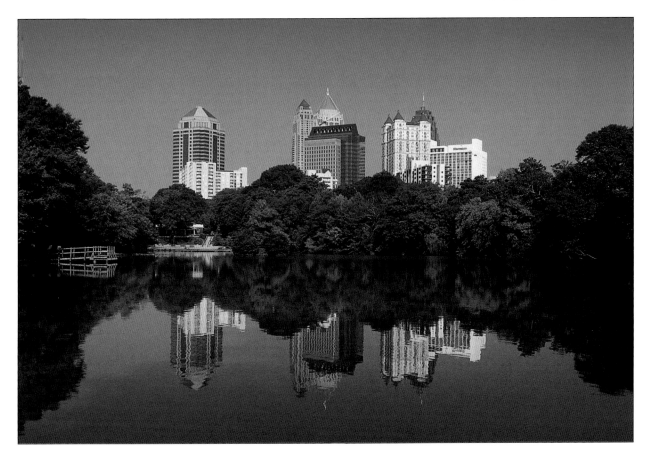

Though none of the original exposition buildings remain, modern high-rises tower over Piedmont Park from the edge of the park west to Peachtree Street, including the 1100 Peachtree Street building at left, the Campanile with its blue glass at center, and the Mayfair condominiums at right.

The Peachtree Hills residential area, established in 1912, marked a further expansion of development north along Peachtree Street—this time, crossing the boundary of Peachtree Creek into present-day Buckhead. It was near here in the heavy woods and deep ravines of Tanyard Branch, a tributary of Peachtree Creek, that the Battle of Peachtree Creek was fought in July 1864.

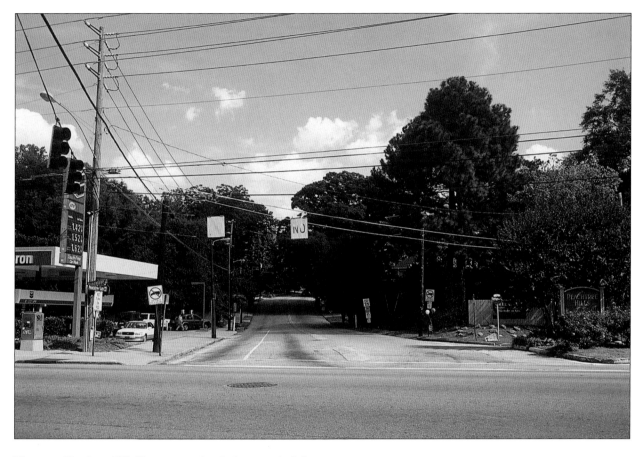

The gates of Peachtree Hills Place are gone, but the house on the hill still stands, though now obscured by trees. In the years following, a number of planned residential neighborhoods appeared in the area, including Garden Hills, Peachtree Battle, and Peachtree Park. Despite commercial development along Peachtree Road, these neighborhoods have remained primarily intact.

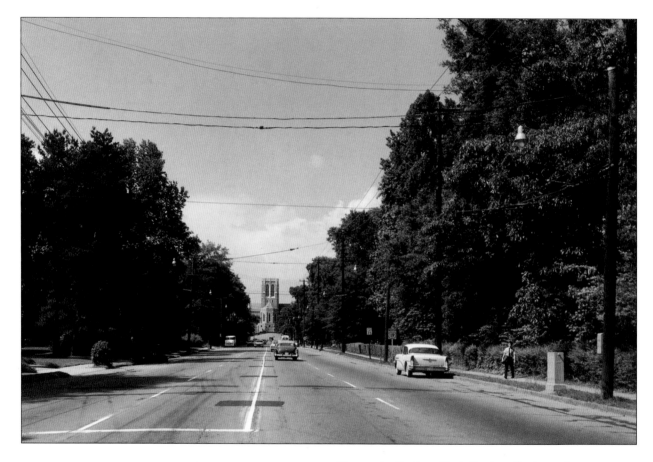

After crossing Peachtree Creek, Peachtree Road ascends a rise in
the terrain to the prominent Cathedral of St. Philips. At this point,
Peachtree veers sharply to the right and Andrews Drive, named for
the James J. Andrews residence that once stood on the site of the
Episcopal Church, turns left. For a number of years, this bend in
Peachtree Road was known as "Dead Man's Curve."

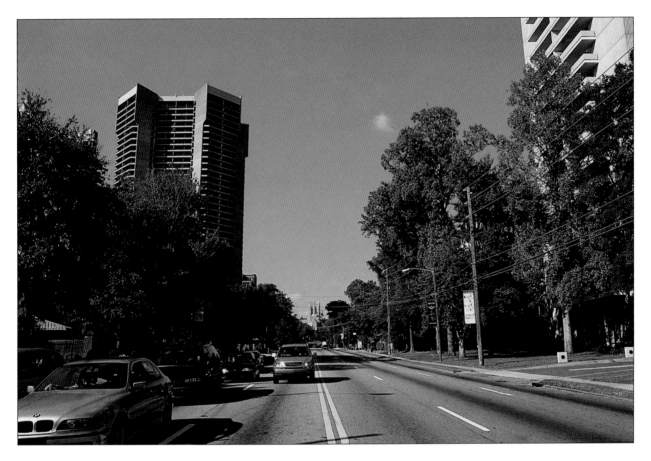

With the addition of the Second–Ponce de Leon Baptist Church and the Cathedral of Christ the King along with the Cathedral of St. Philip, the intersection of Peachtree Road and Andrews Drive is now known as "Jesus Junction." In addition, high-rise condominiums have taken the place of the stately homes that once lined this section of Peachtree; the building on the left is Park Place, location of Elton John's Atlanta home.

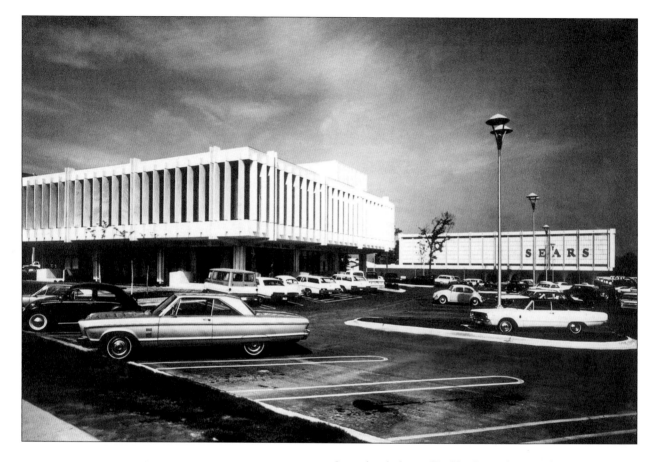

Located in the heart of Buckhead—Peachtree Road and West Paces Ferry Road—the Sears building stood for twenty years as a guidepost for directions along Peachtree Road, as in "Go to the Sears in Buckhead and turn right." At left stands the First Atlanta Bank Building.

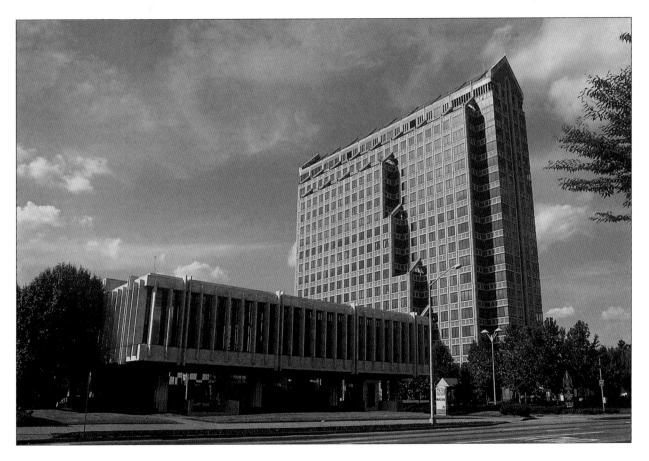

The Buckhead Plaza office building, constructed in 1988, now towers
over the bank building, currently in use—along with many buildings in
the area—as a bar and restaurant for the crowds of people who come to
enjoy the Buckhead nightlife.

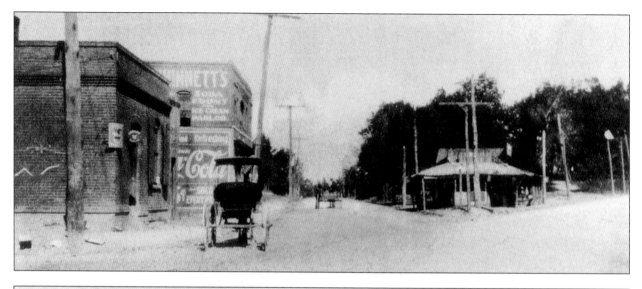

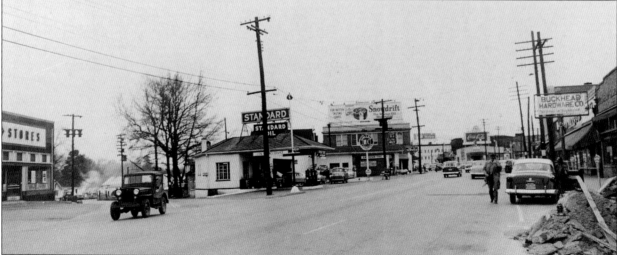

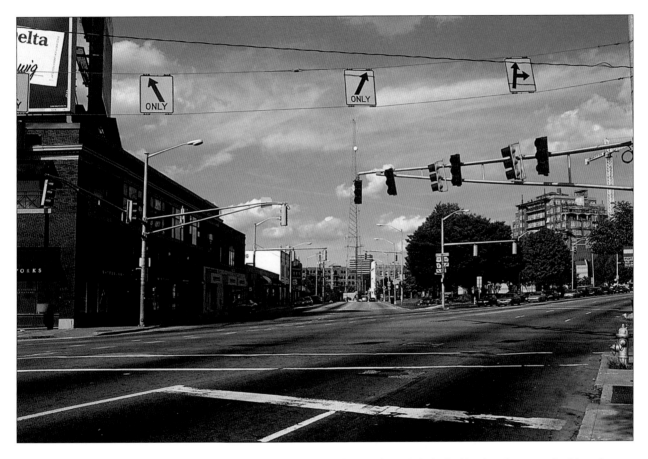

Above left: A buggy sits at the side of the road in 1910 at the fork of Roswell (on the left) and Peachtree (on the right) roads in Buckhead, still considered to be "out in the country" at that time. *Below left*: Even in the late 1940s, Buckhead still had the look of a small-town community; West Paces Ferry is to the left, the Peachtree-Roswell intersection is in the distance at right.

Above: In about 1840, the Buckhead area's name evolved from the posting of a large buck's head as a trophy on a pole near Henry Irby's tavern, standing at the northwest corner of West Paces Ferry and Roswell. Today, the area formed by the Peachtree-Roswell intersection is known as the Golden Triangle.

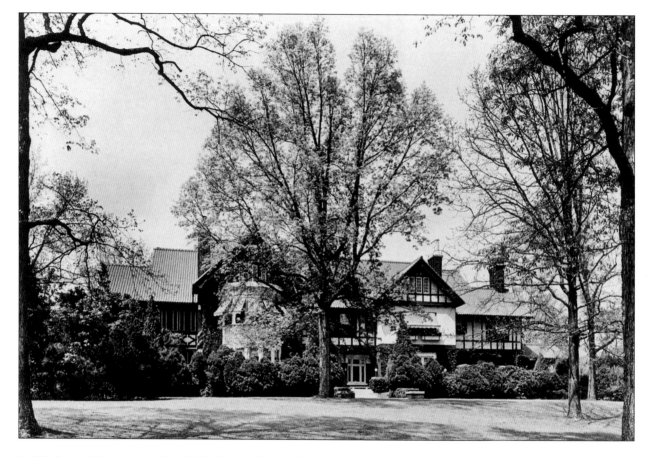

In 1911, former Atlanta mayor Robert Maddox built this Tudor-style house along West Paces Ferry Road, then a quiet, dusty, rural road. Intended as a summer residence, it nevertheless initiated development of the surrounding area as a fashionable residential district of large houses surrounded by considerable property, often suggesting English country estates. As automobiles made escape from the crowded city streets easier and reasonable, the homes became year-round residences.

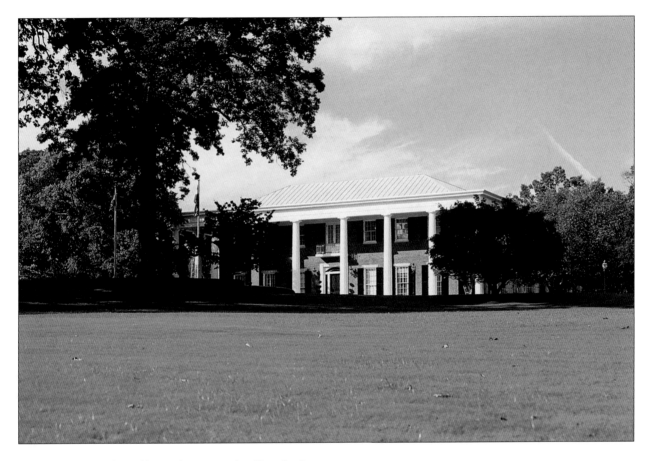

Demolished in 1966, the Maddox residence was replaced by a Greek Revival–style mansion, meant to reflect the state's early nineteenth-century history. Designed by Atlanta architect A. Thomas Bradbury, the house is regularly open to the public and contains a collection of Neoclassical paintings, furniture, and decorative arts, considered one of the nation's finest collections of Federal-period furniture.

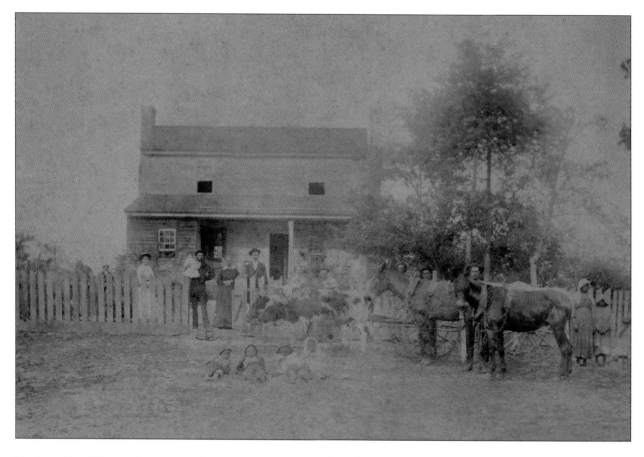

Members of the William B. Smith family and work hands pose before the Smith residence in May 1884. Built circa 1845, the plantation-style home stood near North Druid Hills Road on 800 acres located in DeKalb County, Georgia, until 1969. By that time, its property was located along Interstate 85 and its site was developed as the Executive Office Park. The house, detached kitchen, and outbuildings were then moved to the grounds of the Atlanta History Center—one of the city's first efforts of preservation.

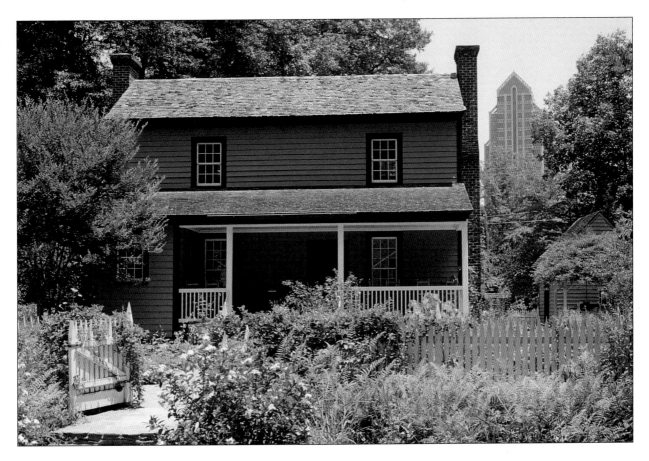

Now known as the Tullie Smith Farm for the house's last occupant,
the farm serves as an interpretive site for Atlanta's agricultural past.
Costumed interpreters lead tours of the house and perform everyday
activities typical of nineteenth-century rural Georgia, including open-
hearth cooking, animal care, blacksmithing, basket weaving, candle
making, quilting, spinning, weaving, and other craft demonstrations.

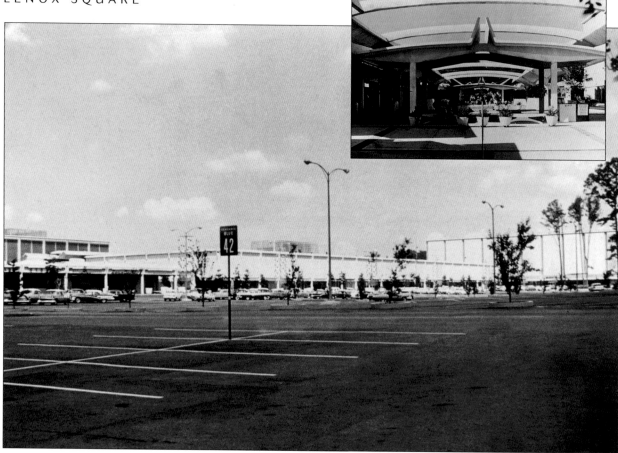

When it opened in 1959, Lenox Square was the first regional mall
in the Southeast, notable for its white concrete canopies and arches.
Initially an open-air mall, it was equipped with 6,000 parking spaces for
shoppers coming to its fewer than sixty stores. Within just a few years,
however, its success instigated a consistent series of expansions,
constant redecoration, and transformation.

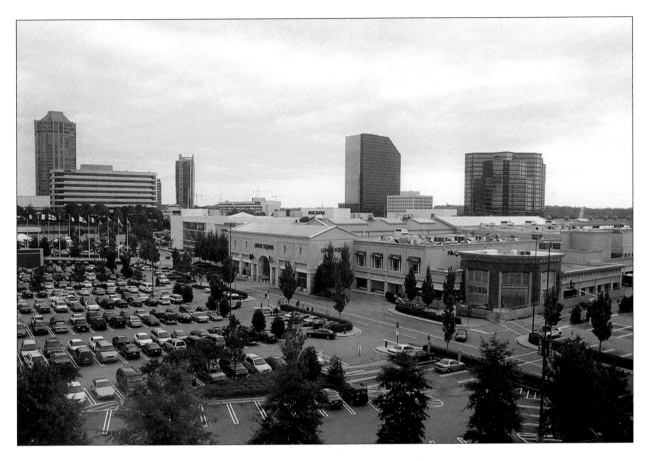

Now with two enclosed stories and nearly 200 stores, Lenox Square,
along with the addition of 100 stores at the adjacent Phipps Plaza, is
the South's premier shopping site. In addition to the shopping mall,
high-rise office buildings, hotels, and residences continue Buckhead's
building boom.

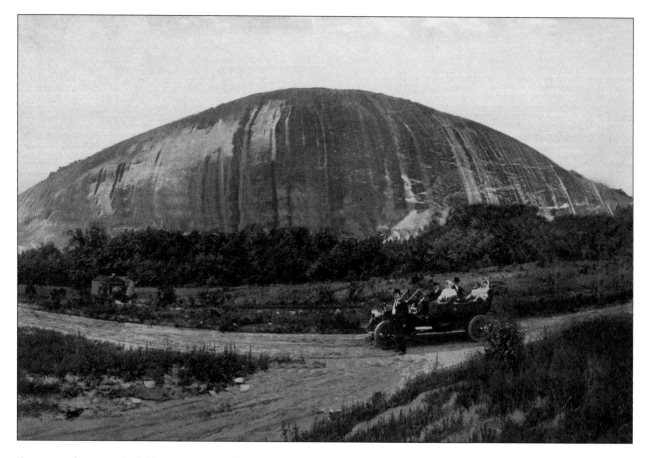

Known over the years as Rock Mountain or New Gibraltar, Stone Mountain is the world's largest mound of exposed granite, rising 825 feet above the Georgia Piedmont. Always a popular tourist attraction, a wooden observation tower was built on its summit in 1838 and the Georgia Railroad, completed to Atlanta in 1845, made stops here at the Stone Mountain Hotel. In 1887, the Venable family purchased the mountain and owned it until the State of Georgia acquired it and surrounding land in 1958.

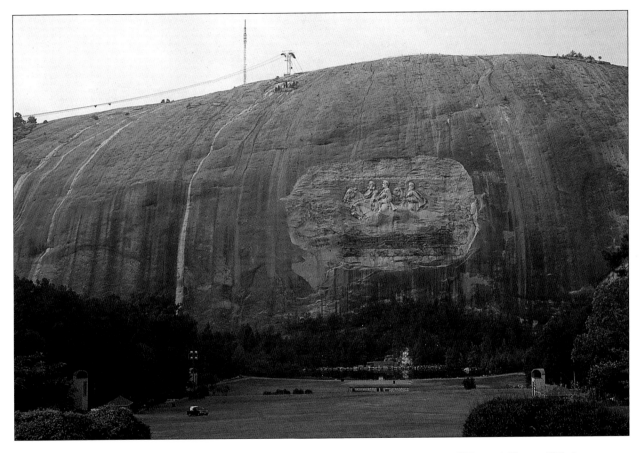

Stone Mountain Park remains a popular tourist attraction, drawing four million annually to visit the world's largest relief carving as well as to entertainment and recreational activities offered on the park's 3,200 acres. The carving, composed of Confederate president Jefferson Davis and generals Robert E. Lee and Thomas J. "Stonewall" Jackson, was begun in 1923. Following a thirty-six-year delay, the three-acre relief was not completed until finishing touches were added in 1972.

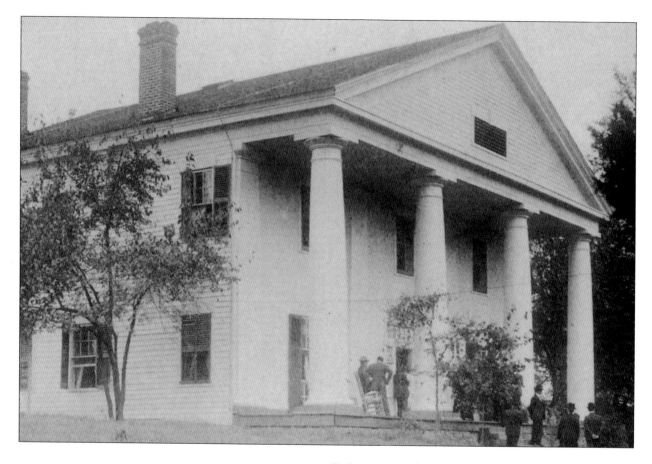

To those searching for Tara—Margaret Mitchell's fictitious plantation home—Bulloch Hall appears as a shining example of what is popularly thought of as Civil War Atlanta. Built by Major James Stephens Bulloch in about 1840, the residence is the sort of white-columned, Greek Revival temple–style house commonly associated with the term "Southern mansion."

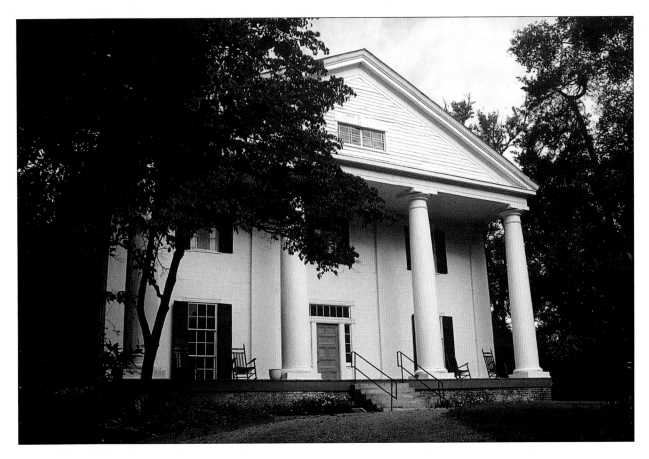

Major Bulloch's daughter, Mittie, was married in the house in 1853—
her son was President Theodore Roosevelt and her granddaughter was
Eleanor Roosevelt, married to President Franklin D. Roosevelt. Today,
the house has been restored and is used as a cultural center and
exhibition space.